carnivalesque

Timothy Hyman
Roger Malbert

D1331379

National Touring Exhibitions

sbc

Published on the occasion of the exhibition *Carnivalesque*,
a National Touring Exhibition organised by the Hayward Gallery,
London, for the Arts Council of England, in collaboration with
Brighton Museum and Art Gallery

Exhibition co-curated by Timothy Hyman and Roger Malbert,
assisted by Miranda Stacey, in collaboration with Nicola Coleby
and Helen Grundy

Exhibition tour

Brighton Museum and Art Gallery
6 May – 2 July 2000
Fabrica, Brighton
6 May – 2 July 2000
University Gallery, Brighton
6 May – 10 June 2000

Castle Museum and Art Gallery, Nottingham
15 July – 10 September 2000
Djanogly Art Gallery, Nottingham
15 July – 10 September 2000

City Art Centre, Edinburgh
21 October – 16 December 2000

Catalogue designed by Alexander Boxill
Printed in England by The Beacon Press

Front and back cover: **Anon**, Flemish, *Satirical Diptych*, c.1520,
(detail), © Collections artistiques de l'Université de Liège

Published by Hayward Gallery Publishing, London SE1 8XX
© The South Bank Centre 2000
Texts © the authors 2000

The publisher has made every effort to contact all copyright holders.
If proper acknowledgement has not been made, we ask copyright
holders to contact the publisher.

ISBN 1 85332 209 1

This publication is distributed in North and South America and Canada
by the University of California Press, 2120 Berkeley Way, Berkeley,
California 94720, and elsewhere by Cornerhouse Publications.

Hayward Gallery Publishing titles are distributed outside North and
South America and Canada by Cornerhouse Publications, 70 Oxford
Street, Manchester M1 5NH (tel 0161 200 1503; fax 0161 200 1504;
email: publications@cornerhouse.org).

Contents

Lenders

Preface

Carnivalesque was conceived by the Hayward Gallery as part of its National Touring Exhibitions programme and has been organised in association with the Brighton Museum and Art Gallery. It is in many respects a sequel to an earlier collaboration between the Hayward and colleagues in Brighton in 1995, when we together presented the exhibition *Fetishism*. Jessica Rutherford, Head of Libraries and Museums and Director of the Royal Pavilion, has entered wholeheartedly into the spirit of this new, and again, provocative exhibition and we are grateful to her for her engagement with it. The idea for the exhibition was originally proposed by Nicola Coleby, Senior Exhibitions Officer at Brighton, and she and her colleague Helen Grundy have remained closely involved at every stage of its development.

The artist and writer Timothy Hyman responded enthusiastically to our invitation to lead the selection process and has done so with visual acuity and sound historical sense. He is largely responsible for the choice of historical works and has written a spirited and erudite essay for this publication; he has been a wonderful partner. Roger Malbert, the Hayward's Senior Curator of National Touring Exhibitions, has taken the initiative on the selection of contemporary works, and he and Miranda Stacey have seen the project through to fruition in every detail. I thank them both for their commitment. Thanks are also due to the medieval art historian Malcolm Jones for much useful advice and an enlightening account in this catalogue of medieval pilgrim badges. Kate Bell, the Hayward's Art Publisher, has edited and overseen all aspects of catalogue production, and it has been sensitively designed by Jane Alexander and Violetta Boxill. Paulette Warner has provided contextual material for the portfolios which form part of our educational materials for the show. I am grateful to her, and to Felicity Allen, the Hayward's Head of Education, for developing an innovative and stimulating programme.

Carnivalesque has been conceived on a relatively modest scale and does not allow an encyclopaedic survey of every aspect of the subject. There is a preponderance of graphic works as it is often in these that imaginative expression is at its freshest and most informal. We have once again benefited from the exceptional generosity of the Department of Prints and Drawings of the British Museum, which has provided an essential core of more than forty works on paper to the exhibition. We are particularly grateful to Keeper Antony Griffiths for maintaining that collection's availability as a vital national resource. Many others have also lent generously, and it is a privilege to be able to include so many works of outstanding quality. We thank all our lenders for making the exhibition possible.

Carnivalesque is launched, appropriately, as the major Festival exhibition in Brighton, where it is shared between three venues. The collaboration of our colleagues in all those galleries has been essential to the exhibition's realisation, and we thank Colin Matthews and Gez Wilson at the University of Brighton Gallery, and Matthew Miller and Saj Fareed at Fabrica. Similarly, colleagues in Nottingham, Kate Stoddart at the Castle Museum and Neil Walker at the Djanogly Gallery, have played an active part in discussions from an early stage. We are delighted that the City Art Centre in Edinburgh, with which the Hayward has enjoyed a long and fruitful relationship, will be the final venue on this national tour.

Many others have been vital to the development of this project and we are especially grateful to Janita Bagshawe, Nicola Bateman, Stella Beddoe, Lilliana Bonilla, Cara Bowen, Bruce Brown, Andrew Causey, Alexandra van Dongen, Joanna Drew, Catherine Ferbos-Nakov, Luc Gobyn, Jerry Gorovoy, Frank Gray, Anthony Howell, Lianne Jarrett, Professor George Knox, Sharon Michi Kusunoki, Julie Lawson, Ruth Lewis-Jones, Karen McCarthy, David Alan Mellor, Pierre Mercier, Marie-Cécile Miessner, Phillida Reid, Ingrid Schaffner, Veronica Sekules, Pippa Smith, Jon Thompson, Madeleine de Terris, Mike Tucker, Robert Violette, Jan Vrommann, Marina Warner and Timothy Wilcox.

The performances by Marisa Carnesky and Anthony Howell in Brighton have been generously supported by The Elephant Trust, to whom we also offer our thanks.

Susan Ferleger Brades
Director, Hayward Gallery

THE MILLER'S MAN

Grinding Old People Young.

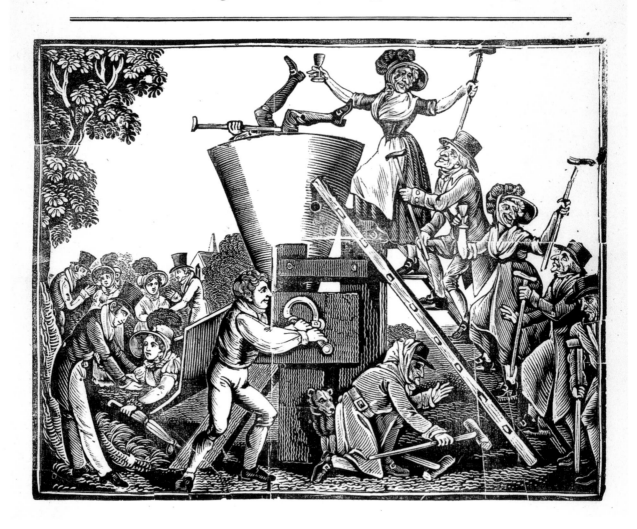

38
Anon, Broadsheet
The Miller's Man, Belfast, 1840
The British Museum, London
© British Museum

Author's Foreword

Without some experience of the actual Carnivals enjoyed by millions throughout Europe, I could not have written about *carnivalesque*. The imagery of any historical survey – Ship of Fools, Cock-rider, Wild Man, the Mill that grinds Old Women into Young – is still to be encountered in contemporary Carnival parades (interspersed with, say, Viagra, and the legs of Monica Lewinsky disappearing under Clinton's desk). Modern Carnivals are split between the officially-sanctioned spectator events, and the more communal, sometimes anarchic activities, difficult of access to an outsider – and probably best experienced before the age of twenty-five. In Cologne, the vast televised procession of *Rosenmontag* seems dominated by the local chocolate manufacturer Ludwig, whose products are showered from the floats. But the Saturday before, I've loitered with my host Hans Muhlenbein beside the Rhine, in the Altstadt, enjoying the spectacle of *Geistnacht*. Angels in white plastic wings are boozing at sausage-stalls with devils (their red horns flashing electronically); and many a nun of a strange order skips beside a Franciscan in high heels. A small brass band is playing. For a moment, as we all find ourselves swept suddenly along into an unprogrammed procession, I feel some sense of participation.

. . . When Johan Verberckmoes gets me to Binche on the Tuesday, it is still dark; as we step out of the station, we see a group of 'Gilles' toiling up the hill towards us. The little troupes move about the streets in a strange hobbled dance-step to the beat of the drum, bells jingling at the waist, clogs clattering.

The passage through the drizzle of these humped figures – American footballers, or the all-male remnant of a Neanderthal family – is a very intimate and poetic rite, inducing a trancelike state in all who follow . . . A few days later, I meet up with Lionel Lambourne, my Carnival mentor, a bit disheartened after a week searching out the more 'authentic' festivals, and always in the wrong place at the wrong time. 'It's like chasing rainbows,' he sighs. But in Basle, Beatrix Everett gets us to the *Morgenstreich* at 4 a.m. on the Monday. All is dark; then, in the silence, moving lights suddenly appear, and a marching music of drum and piccolo from every direction. As they come into sight, I realize that all twenty thousand are masked – and thereby transformed into strange beings, animal-headed gnomes, perhaps the invading armies of the dead. As well as the various 'cliques', tiny groups of three or four, and even *solitaires*, are constantly crossing on their own trajectories, holding their tune, adding to the beautiful cacophony, which remains in my head for days afterwards . . . When I talk with artist friends who've grown up in a Carnival culture, I realize that these are only glimpses of a much more encompassing totality, which will always remain elusive.

Among so many who have helped in such various ways, I want to thank:

Professor David Bindman, Carol Brown, Professor Susan Canning, Frances Carey, John Cherry, Canon Rex Davis, Joanna Drew, Andrew Edmunds, Beatrix and Mike Everett, Kate Foley, Mireille Galinou, Dr David Goodway, Antony Griffiths, Dr Christa Grossinger, Robert Hoozee, Neil Jeffries, Professor Gabriel Josipovici, Lionel Lambourne, Simon Lewty, Professor Charles Lock, Adam Lowe, Professor Nico Mann, Lino Manocci, Richard Maxwell, Professor David Alan Mellor, Wolfgang Mudra, Hans and Hannelohre Muhlenbein, Sheila O'Connell, Professor Cesare Poppi, Heidrun Rathgeb, Simon Turner, Professor Johan Verberckmoes, the staff of the Museum of London and the staff of The British Museum.

Timothy Hyman

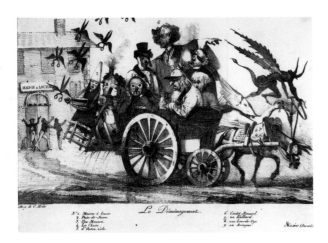

49
Eugène Delacroix
The Censors Moving House (*Le Déménagement de la Censure*), 1820
The British Museum, London
© British Museum

My essay is dedicated to the memory of my twin brother, Anthony Hyman, always a good laugher

A Carnival Sense of the World
Timothy Hyman

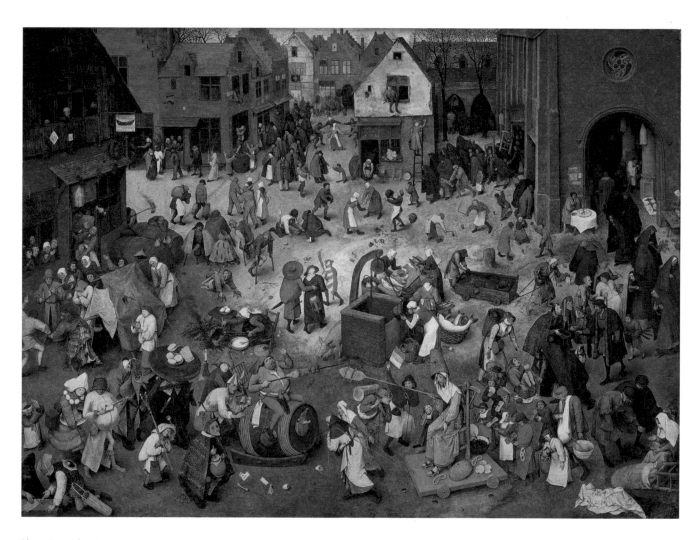

Pieter Bruegel
The Battle between Carnival and Lent, 1559
Oil on panel
118 x 164.5 cm
Kunsthistorisches Museum, Vienna

The imagery assembled here may at first appear bewildering. It deals with masks and monsters, bottoms and enemas, feasting giants and misshapen birdmen, and often with fools: fools capped–and–belled, fools hatched from eggs, whole ships crowded with fools, processions of fools. Spanning seven centuries and at least as many nationalities, all this might be taken for some free-floating anthology of 'The Fantastic'. Yet what links so many of the artists who made these works – Bruegel and Callot, Domenico Tiepolo and Goya, Ensor and Beckmann – is much more specific: each was nourished by Carnival.

I was already in my forties before I really knew the meaning of the word: either the literal definition, the 'giving up' or 'farewell to' meat (*carnem levare* or *carne vale*) or the rituals that have become associated with this end–of–winter festival, still so important throughout much of mainland Europe. In the days leading up to Ash Wednesday, for example, all the fat in the house must be consumed; hence Mardi Gras, 'Fat Tuesday'. While Carnival is first recorded as a pre-Lenten feast only in the later Middle Ages, most anthropologists locate its origins much earlier, in pre-Christian ritual and especially in the Saturnalia – the period of licence and excess, when inversion of rank was a central theme. Slaves were set free and given the right to ridicule their masters; a mock-king was elected; the lost Golden Age of the deposed god Saturn was temporarily reinstated.[1] Affinities to more distant traditions – the Jewish *Purim* or the Indian *Holi* – suggest a structure deeply implanted in mankind: a moment in each year when for a few days the laughter of disorder comes out from the margins and assumes centre-stage.

Bruegel's *Carnival and Lent* is a compendium, setting out to chart every aspect of carnival tradition – its foods, its masquerades and its brief madness – as well as the Lenten penitence that will follow. Just as his near-contemporary Rabelais created, in Mikhail Bakhtin's phrase, 'an encyclopaedia of Folk-culture', so Bruegel here, as in his *Netherlandish Proverbs* and *Childrens' Games*, creates a panorama of popular custom. But the divided structure of the picture makes explicit the mutual interdependence of Carnival and Lent; in the beautiful little emblematic image now in Copenhagen, Carnival is a fat smiling monk, bitten into by the miserable Lenten starvelings.

Pieter Breugel
The Strife of Lent with Shrove-Tide,
1540–69
Oil on panel
Statens Museum for Kunst, Copenhagen

In England Carnival has been almost entirely excised from our visual traditions. London's National Gallery may seem limitlessly rich, yet you could walk all through it and not find a single painting for this survey. Imagine the effect were we to encounter, in one of those quiet Flemish rooms of the Sainsbury Wing, the folding diptych of *c.*1520 from Liège, part of which is reproduced on the cover of this book. On the closed exterior, a smiling parody-prophet bends oddly forward, holding in his left hand a scroll that exhorts us to leave it shut. But of course we disobey, and open the diptych anyway; and we find ourselves suddenly behind him, assaulted by the sight of his 'brown cheeks', as, with his right hand, he spreads his spotty buttocks. The dark substance between, spilling over his lowered pants, may at first read as excrement, but turns out to be thistles. The scroll reads, roughly translated: 'You can't say I didn't warn you.' And opposite, he taunts us as children still do, pulling down his eyelids and sticking out his tongue: 'I made you jump out of the window!' So this is an elaborate burlesque altarpiece, which substitutes for the traditional diptych (icon flanked by pious devotee) an exposed bottom hinged to a grimacing head. It is, in its way, a masterpiece, luminous in colour and brilliantly naturalistic in observation, as when we glimpse the scrotum through the thistle. This exceptionally refined execution places it in the category of high, or at least expensive, art; Phillip II of Spain is known to have enjoyed a similar diptych at the Escorial. But it is really a kind of portable joke-mechanism, akin to a jack-in-the-box. Its purpose is not aesthetic or contemplative: it exists to make us laugh.

Placed in our context, however, the Liège diptych begins to make a different sense. Its parody of a religious format, its structure of inversion (hinging back to front, top to bottom) relate it to the topsy-turvy world of Carnival. In America a 'carnival' has come to mean a fairground; in England, a procession of street floats. We need to rediscover the richer sense of Carnival: as emblematic of the liberty of the imagination; as an ideology of unbuttoning.

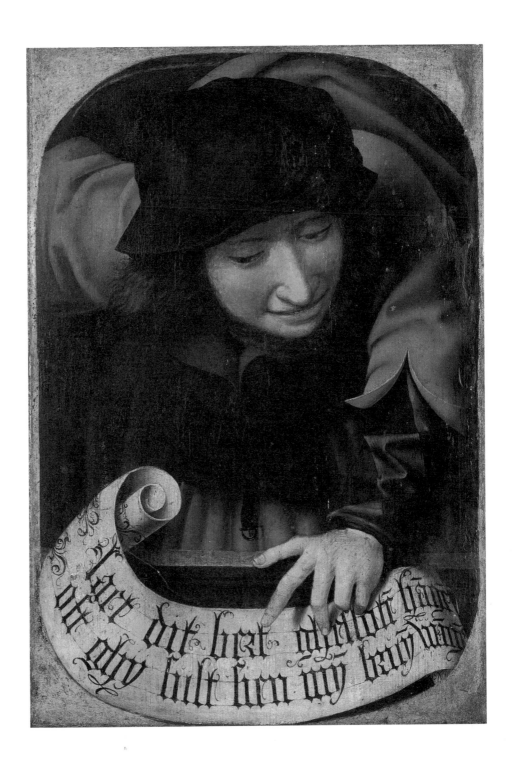

86
Anon, Flemish
*Satirical Diptych, c.*1520
(Interior images illustrated
on pp. 12–13)
Université de Liège (Belgium),
Collections artistiques
© Collections artistiques de
l'Université de Liège

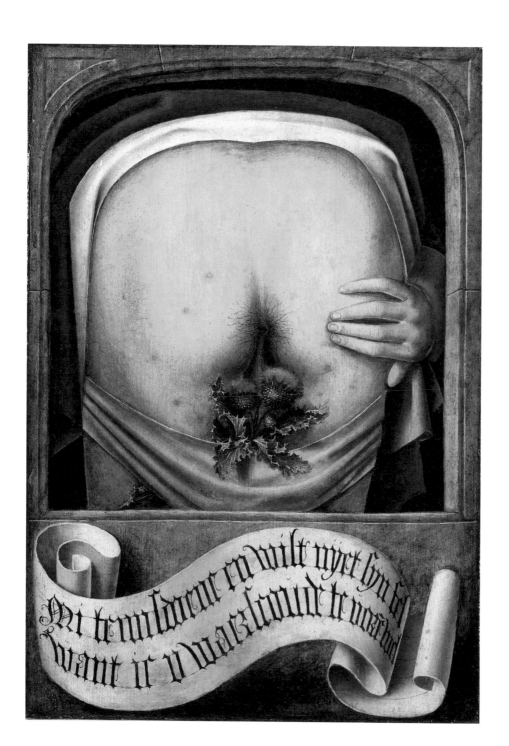

Bakhtin in the History of Laughter

> 'The Carnival sense of the world, permeating these serio-comic genres from top to bottom, determines their basic features and places image and word in them in a special relationship to reality There is a weakening of its one-sided rhetorical seriousness, its rationality, its singular meaning, its dogmatism . . .'[2]

At the end of the 1930s, in the midst of the Stalinist purges, a crippled teacher exiled in a drab provincial town embarked on a doctoral thesis about Laughter. Mikhail Bakhtin (1895–1975) had already written on the humour of the grotesque as manifested in the novels of Dostoevsky and Gogol.[3] But now he turned to an earlier kind of laughter, to Rabelais and 'the popular culture of the Middle Ages'. The word *carnivalesque* had been used before Bakhtin by historians such as Ernst Cassirer[4]; in *Rabelais and his World*, however, it is endowed with a new and 'broadened' meaning, until it becomes a kind of incantation. Bakhtin's *carnivalesque* invokes a laughter linked to the overturning of authority; it is 'that peculiar folk humour that has always existed and has never merged with the official culture of the ruling classes'.[5]

The Rabelais dissertation was forgotten for over twenty years, until Bakhtin was rediscovered in the 1960s. Its publication in France happened to more or less coincide with the short-lived student revolution of May 1968; and suddenly, for many young intellectuals, including Julia Kristeva, *carnivalesque* became something of a battle-cry. Those first Western responses have since been ridiculed for their 'naïve enthusiasm'. Historians and anthropologists alike have found much at fault in Bakhtin's account of Carnival. Nevertheless, his 'mythology of laughter' remains more compelling and more comprehensive than any subsequent text.

So *carnivalesque* signifies not the actual festival, but an *idea* – an idea perhaps especially attractive to those who grow up in worlds purged of the grosser imagery of popular festivity, worlds forever Lenten. Certainly the vein of exuberant and grotesque fantasy I found in Bruegel and his successors first

[handwritten margin notes: "Bakhtin's 'carnivalesque'" and "doesn't refer to the special event but the idea behind it."]

appealed to me as a young art student in the early 1960s, as a resource – as antidote and alternative. (Antidote to grey lifeless post-war London streets; alternative to those oppressive constructions by which Cézanne led to Cubism, Cubism to Mondrian, Mondrian to Kenneth Noland . . .) In reality, however thoroughly the Puritan cleansing suppressed the ceremonies of Carnival in the English-speaking nations, carnivalesque subcultures have often flourished: Panto, Phantasmagoria, Fairground, End-of-pier And it would be in the London of the 1780s, when the dominant bias was so much towards neo-classical convention, that there emerged one of the richest of all carnivalesque genres – the tradition of caricature that culminated in the vision of James Gillray. Perhaps we can say that every truly carnivalesque art is fuelled by an absence and a need; and it may be precisely where laughter is most forbidden that the carnivalesque becomes most meaningful.

An Alternative Canon

'The classic canon is clear to us, artistically speaking: to a certain degree, we still live according to it. But we have ceased long ago to understand the grotesque canon . . .'[6]

In *Rabelais and his World*, Bakhtin set out to reconstruct the grotesque canon – and that, in the visual realm, is what this survey also attempts. It is structured by four themes – The Tumultuous Crowd, The World Turned Upside-Down, The Comic Mask, The Grotesque Body – all of them extending through different times and cultures. These four core themes constantly overlap; and within each heading one finds groups of related images, pointing to further perspectives.

The Tumultuous Crowd

Beneath the crumbling hulk of James Ensor's *Cathedral* there stretches a sea of Lilliputian figures – hundreds and hundreds of them. But they are of two kinds: the orderly ranks of identical soldiers, rendered in a semaphore of dots and lines; and then, nearer to us, a sudden transition to a zone where all has become cursive – each smiling head marvellously individualized, touched into

3
James Ensor
The Cathedral, 1886
Museum voor Shone Kunsten, Gent
© DACS 2000

being by the tiny marks of the etcher's needle. This foreground zone reveals itself as the laughing 'many-headed monster' of the Carnival mob, sporting the most diverse and fantastical headgear – turbans, sombreros, boyar fur-caps, three-foot-high cylinders The Carnival crowd comes in many forms, but Ensor's image embodies its potential to create at least a temporary revolution. In 1886, the year the etching was made, Belgium was convulsed by enormous popular demonstrations against a dictatorial king and a Catholic reactionary government. Ensor had strong anarchist sympathies; the freedom of his autonomous line, the wild loops and squiggles by which he creates his disorderly realm, are wonderful graphic *equivalents* to his libertarian aspirations.

The World Turned Upside-Down

This Carnival overturning generates a new range of imagery; everything known to us can be shown in systematically altered relationship. We see in popular prints fishes flying above the clouds, birds beneath the waves (see pp. 86–7); we glimpse in Bruegel and his contemporaries *The Land of Cockayne* where all can be idle, where work is forbidden by law. We are jolted into a healing laughter; it is all far more vivid than our imprisoning everyday lives, and we are for a moment free. Yet the absurdity of topsy-turvy imagery gives the Carnival game away: everything remains unchanged, all will return to the *status quo*.

The Comic Mask

Bakhtin calls the mask 'the most complex theme of folk-culture'; it is certainly central to Carnival. Typically, he writes of it almost always in positive terms, as an enlargement, freeing the individual from class and even from gender. That our word 'mask' should derive from the Arabic for clown, *maskharat*, makes explicit the links to laughter – yet the mask may also, as in Ensor, be used to conceal; and in children it arouses a simultaneous fascination and fear, recalling its origin in magical practices. In many Carnivals, the mask appears in both 'Ugly' and 'Beautiful' types. This survey emphasizes the darker, more infernal aspect of the mask.

The Grotesque Body

The classical ideal had already crossed the Alps when Hans Weiditz (1500–36) invented his ugly pair (see pp. 18–19); such grotesque figures may be best understood as conscious repudiations of the closed body of the Renaissance, in which all protuberances will be smoothed down, all apertures closed. Weiditz was not a mere journeyman: he made a famous panorama of Augsburg, and illustrated Petrarch. But he here asserts what Bakhtin calls the 'Unfinished' body, parading its lumpy extensions, pregnant with liquids. Under the *Fat Man* was once an inscription, beginning: 'I am a fine winebag / carrying my paunch in the wheelbarrow', and above his Desperate Dan chin erupts an arc of projectile vomit. His female counterpart is heiress to the medieval *grylli* (see the misericord on page 27) though the bared breasts hanging almost to her feet give this woodcut a crueller edge.

James Ensor
The Cathedral, 1886, (detail)
Museum voor Shone Kunsten, Gent
© DACS 2000

123
Hans Weiditz
Fat Man, 1521
The British Museum, London
© British Museum

124
Hans Weiditz
Grotesque Woman, 1521
The British Museum, London
© British Museum

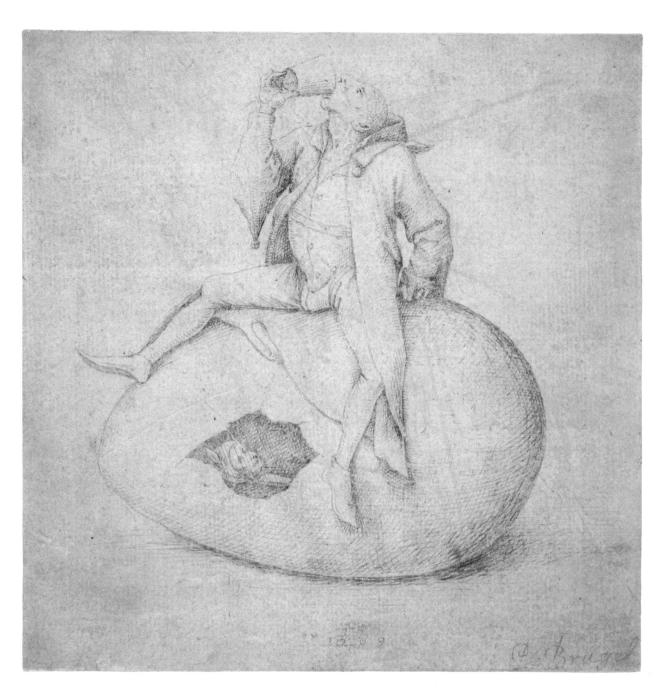

44
Pieter Bruegel (or Crispin Van den Broek after Pieter Bruegel)
Fool Drinking on an Egg, c.1559
The British Museum, London
© British Museum

On the Conjunction of Egg and Fool

In the British Museum's delicate silverpoint drawing, close in to, if not actually by, Bruegel, a fool sits drinking astride an enormous egg. We recognize him as a fool by the bells on elbow and collar, and the ass's ear on his hood; inside the egg we glimpse his *marotte* – the jester's dummy, bauble or sceptre, which is his second self, and with whom he conducts much of his conversation. An engraving of 1559 made from this drawing identifies him as a drunken sot, but does not clarify the egg symbolism. Has he emerged from the egg, as hollow as himself, leaving his *marotte* behind? Or is he drinking in order to hatch the *marotte* into a full-grown fool? Eggs, like fools, are everywhere in Bruegel – and the conjunction was already much used by Hieronymus Bosch,[7] suggesting a popular or proverbial source. We find it again in the coarse but pungent little panel known as *The Everlasting Regeneration of Foolishness,* where a Great Hen is hatching any number of fools. In the tavern behind, every window is crowded with spectators; and on this great stage of fools they pull at one another's noses, play with their codpieces, babble to their baubles The couple on the right can probably be elucidated through another Bruegel image of 1559, his magnificent engraving *The Witches of Maleghem,* whose central theme is the surgery by which folly may be cured. The sorceress and her four scalpel-wielding assistants are itinerant quacks, and the citizens of Maleghem, or fool town, clamour for their services. Their mask-like visages make a terrible group – wall-eyed, cretinously grinning, with tongues protruding – while another fool, under the table, has his lips padlocked. All show on their brow the egg-like 'stone' of folly, whose treatment consists of first extracting it, then funnelling pints of physic through the hole, directly into the skull. A huge empty egg (labelled *P. Brueghel inventor*) has been utilized as an operating theatre. The jovial patient is, we might say, 'losing his marbles', and we see them leaking out through the crack, as from a rectum. Across the whole of this crowded image, Bruegel conducts a brilliant visual punning of fool stones, eggs and coins.

Almost two-and-a-half centuries later, in the very different culture of Venice, we encounter the egg motif again, one of the first in the series of 104 pen-and-wash drawings sometimes known as *The Life of Punchinello (Pulcinella)*, made by the

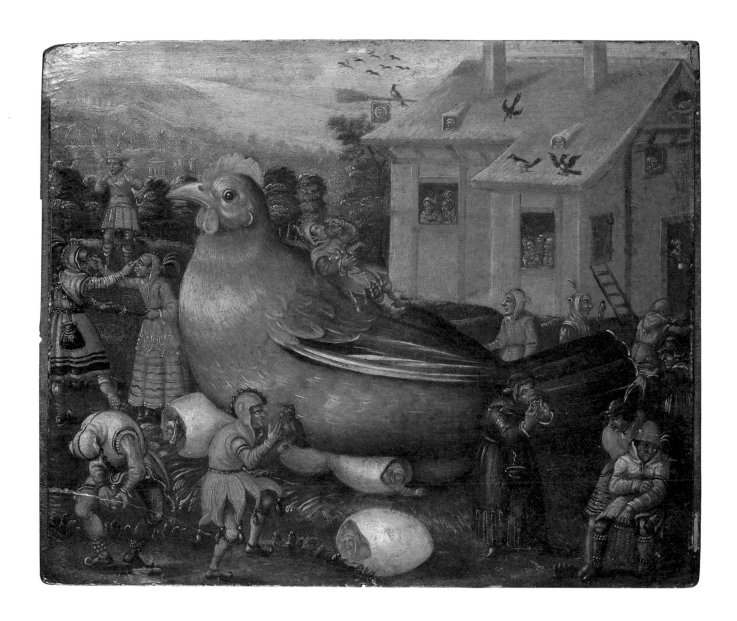

39
Anon, Flemish
The Everlasting Regeneration of Foolishness
(A Great Hen Hatching Fools), 16th century
Université de Liège (Belgium), Collections artistiques
© Collections artistiques de l'Université de Liège

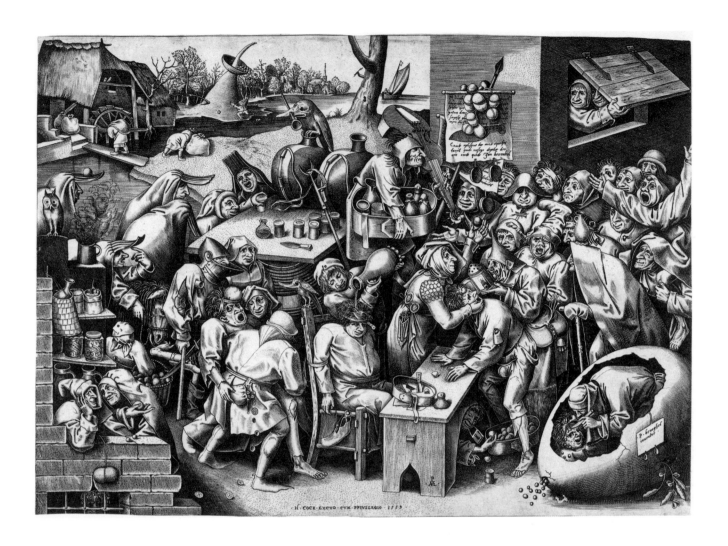

45
Pieter Bruegel
The Witches of Maleghem, 1559
The British Museum, London
© British Museum

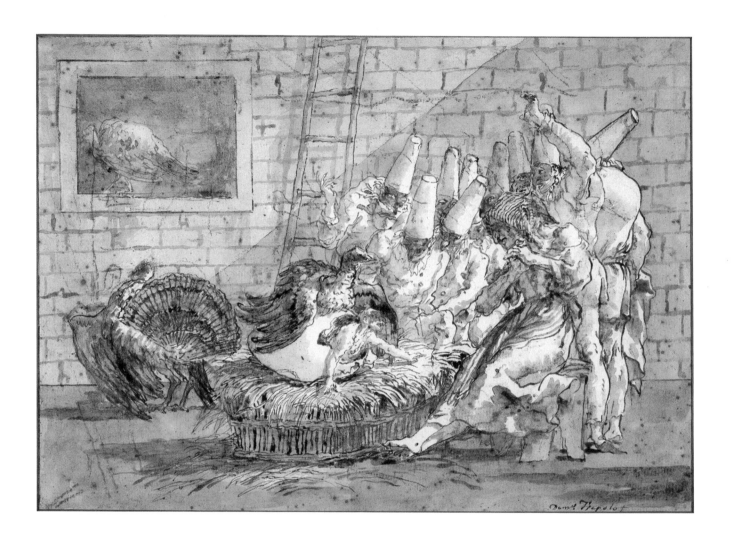

58
Domenico Tiepolo
The Birth of Punchinello, 1802
Executors of the late Sir Brinsley Ford

elderly Domenico Tiepolo. 'Pulcinella' means 'little chicken', and the birth occurs from a colossal egg, hatched by a turkey. But the conjunction here suggests another line of interpretation: not, as has sometimes been proposed, alchemy, but Carnival. Eggs, commonest of all the soon-to-be-forbidden foods, were always pervasive in Carnival. The laying cycle is at its height in February, often producing a glut; yet the egg remains superfluous until, forty days later, it returns as a key emblem at Easter. At Carnival time, eggs become missiles: eggs, not oranges, were thrown at the Belgian town of Binche until the late nineteenth century; in Venice there was the more refined tradition of pelting one's inamorata with hollowed-out eggshells filled with rosewater. And there is also the deep identity of fool with cock – lustful, vain, given to strutting display. The famous Quentin Massys *Portrait of a Fool* has him bearing a fowl on his head. The medieval jester's three-pointed hood was originally a 'cock' in the sense of a phallus and testicles – as we can see, for example, in a beautiful fifteenth-century ceramic head now in Lincoln. Domenico Tiepolo's 'little chicken' has very much the same physique – paunchy trunk on skinny legs – as Bruegel's drunkard. So the fool is – like Papageno in *The Magic Flute* – a bird-man. Of course, none of this can really be said to 'explain' the mysterious conjunction, which is just one of many such enigmatic images that resonate across the centuries.

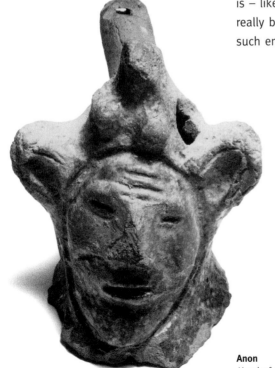

Anon
Head of a Fool, 15th century
Ceramic
Found at Tattershall Castle, Lincolnshire
City and Council Museum, Lincoln

The Lost Worlds (1375–1750)

Bakhtin wrote of 'a system of popular-festive images that was developed and went on living for thousands of years.'[8] This survey covers a mere 700, beginning in the later Middle Ages, when the pre-Lenten Carnival first emerged alongside other ceremonies of inversion, such as the Feast of Fools. A letter of 1495 from the Theological Faculty of Paris tells how:

> 'priests and clerks may be seen wearing masks and monstrous visages at the hours of office. They dance in the choir dressed as women They eat black puddings at the altar while the celebrant is saying mass They cense with stinking smoke from the soles of old shoes. They run and leap through the church'[9]

At Saint-Omer the clergy turned their clothes inside-out; the lay Franciscans at Antibes held their books upside-down. Whatever the origins of such rites, they converge with Carnival, which is perhaps best understood as itself a feast of folly.

While Romanesque art certainly has its share of comical monsters and demons, it is only in the thirteenth century that licence was given for a new kind of secular ribaldry, in the margins of manuscripts and in the very heart of the monastic church. For monks standing at prayer hour after hour, tip-up seats were provided as a 'mercy' (*misericordia*). The word has come to refer to the rich carvings – misericords – on many choir stalls; essentially a hidden art. The dark underside, the hinged mechanism, the buttock-prop – all predisposed this art towards topsy-turvy; towards a sudden laughter, as one turns up 'Wife Birching Husband' or 'Hare Riding Hound'. In two misericords of *c*.1410, the peasants quietly flailing seem unaware of the *grylli* or legged-heads tip-toeing up behind them; the labourers in the haycart indifferent to the strange draped creatures, at once lizard and eagle, whose long necks peck at the chaff. The implication could be of two worlds – the everyday and the unseen/archaic – existing side-by-side. Yet the medievalist Michael Camille argues that such 'monsters' are themselves part of the everyday:

29
Anon
Misericord: *Two men in tunics threshing wheat with two flails, flanked by monsters*, *c*.1410
Victoria & Albert Museum, London
© The Board of Trustees of the Victoria & Albert Museum

30
Anon
Misericord: *Man loading farm cart with sheaves, flanked by monsters*, *c*.1410
Victoria & Albert Museum, London
© The Board of Trustees of the Victoria & Albert Museum

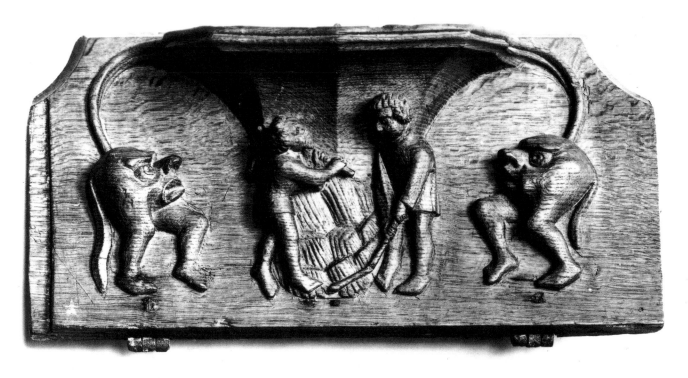
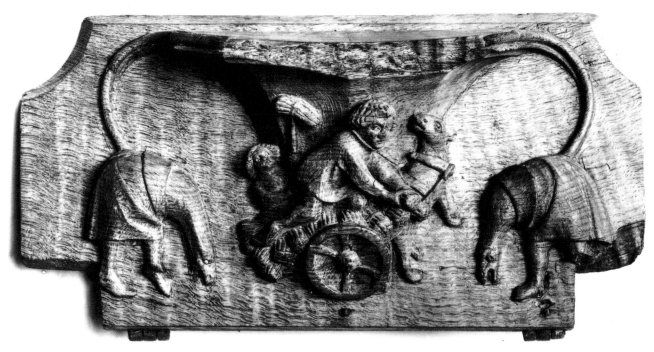

'. . . in fact, they would have been visible in many fourteenth-century [sic] villages at harvest-time. They are clearly depictions of men in the mumming and hobby-horse costumes used in folk-rituals.'[10]

Perhaps. Or does that underplay the strangeness of Carnival transformations? When masked figures mingle with the crowd, the frisson is both humorous and uncanny. A rather earlier misericord from Lincoln Cathedral (where the Feast of Fools is documented over a long period) has the everyday scenes at the margins, each relief beautifully set against grooved 'fields' of corn; while at the centre a finely-carved figure rides astride a giant cock, strikingly akin to the cock-riders who still feature in the Carnival at Rottweil in South Germany. Holding the neck somewhat as a phallic extension (the head has been broken off, probably in the Reformation) he is pecked at by the same wild birds who, in the margins, swoop on the sower's seed and gobble from the sack.

In an astonishing collection of medieval badges now in Rotterdam, the leftwards procession of *Three phalluses carrying a crowned vagina* (*c.*1375–1425) is a masterpiece (see p. 101). The metamorphosis is perfect – the glans doubling as lowered helmet, the hairy scrotum as breeches or paunch, and, under the gallant little tail, delicately modelled legs carrying the phallus so convincingly along. Could this burlesque – the elevation of the anti-virgin – reflect the actual 'diableries' of a Carnival procession? Genitalia appear again – winged, legged, stilted – in other slightly later badges; and, in one hilarious example, two little maid servants tend a penis, standing inside the trousers. Might such brooches have been openly worn at Carnival time? Or were they the medieval equivalent of the reversible tie?

● ● ●

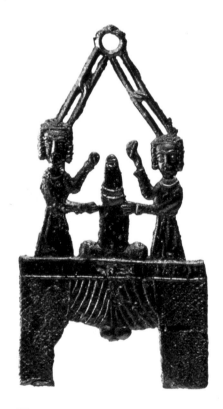

27
Anon
Two women with phallus on top of trousers, 1400–50
Found in Bruges, Belgium
6.3 x 3.3 cm
H.J.E. van Beuningen Collection

Hieronymus · Bos · Inuentor ·　　　ÆE.

Cock excudebat · 1559
cum gratia et priuilegio

| Daer | platbroeck | speelman | is | en | stierman | in | de | bane | | En | al | tiert | syn | ghefelscap | datse | moghen | sweeten |
| Daer | sien | hem | de | voghelen | voer | eenen | huyben | ane | | Het | sullen | de | sanghers | in | de | blau | schuyte | heeten |

43
After Hieronymus Bosch, engraved by Jerome Cock
Ship of Fools, 1559
Private collection, London

The legendary vagabond-jester Till Eulenspiegel (literally 'owl-mirror', punned in Flemish as 'Tyl Wipe-your-arse') was supposed to have flourished around 1350. His pranks, mostly excremental and bottom-exposing, were printed in German in the 1500s,[11] when Sebastian Brant's *Ship of Fools* – published on Shrove Tuesday, 1494 – was already a famous book. Both were illustrated with woodcuts; and alongside this burgeoning 'Fool-literature' (*Narrenliteratur*) there developed a rich visual counterpart which included broadsheets containing satirical verses, of the kind still distributed today on the Carnival streets. A whole alphabet of disorder is in full swing at *The Wonderful Spinnenstube*,[12] to the sound of bagpipes, as trousers are lowered, pots broken, stools overturned and couplings get underway. Erhard Schön's *The Fool-eater* (*c.*1530) bears a text by Hans Sachs, the *Meistersinger*. He tells of encountering two giants on a walk: one, who can only eat men who are master in their house, is starving; the other, however, consumes only fools, and is fat on the current glut. The woodcut shows him lolling in his processional chariot, chewing a leg ripped off a little fool dressed in full cap-and-bells; another is impaled on a spear. As the British Museum catalogue to an exhibition of German Renaissance prints tells us: 'Figures of giant fool-eaters participated in the Carnival parades in Nuremberg in 1508 and 1522, when they made a particularly strong impression on those who saw them'[13]

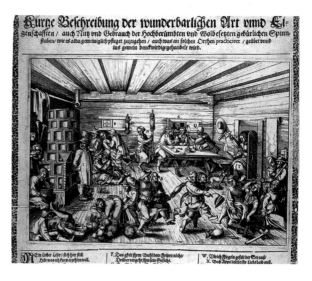

40
Anon, German
The Wonderful Spinnenstube, c.1650
The British Museum, London
© British Museum

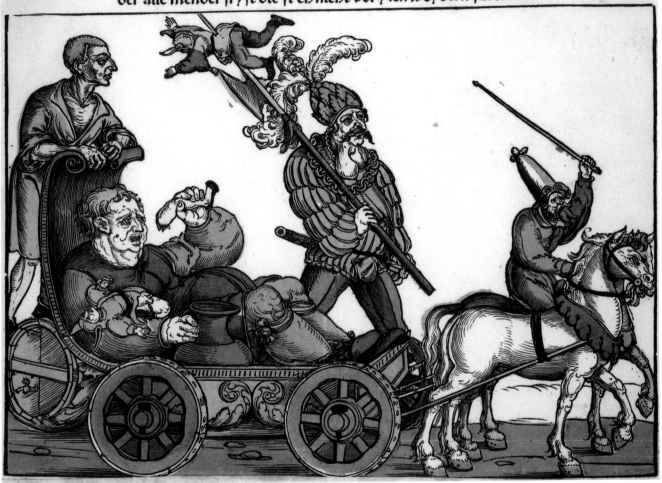

Eigentliche newe zeitung von dem narren fresser/seinem knecht/vnd von dem hungerigen man
der alle mender fryst die si ch nicht vor yren weybern furchten.

57
Erhard Schön
The Fool-eater, c.1530
The British Museum, London
© British Museum

Another Nuremberg designer was Peter Flötner (*c.*1486–1546), famous as a fountain-sculptor, and also for a pack of cards set in the land of Cockayne; on one card, pigs roast excrement on a spit; on another, they devour it. In the powerful woodcut illustrated on page 34, a crutched dwarfish *Fool*, with a pot stuck to his backside, proffers a pile of excrement on a cushion: the goose perched on his head leans forward to eat it. The same cushioned excrement appears in the foreground of *A Human Sundial* – the most in-your-face of all these images; we're confronted with spread legs, codpiece unbuttoned, turd emerging. The hourglass on which one foot rests contains not sand, but shit. Bakhtin sees Rabelais's constant emphasis on the 'lower bodily stratum' as an affirmation, an abundance of life: shit fertilizes. But in visual imagery, such excremental display can seem more aggressive than funny. In Northern Europe, and especially in England, the Reformation was already underway, with iconoclasm its 'central sacrament',[14] and all ritual festivities, including Carnival, banned. Flötner's *Sundial* seems an absurd conflation of two contraries: the clever instruments by which time is computed, and the basest, most 'fundamental' human animal. If the early sixteenth century is an epoch of cleansing and new regulation, is the excremental art of Flötner and his German contemporaries a kind of dirty protest?

● ● ●

104
Peter Flötner
The Procession of Gluttony, 1540
The British Museum, London
© British Museum

21
After van de Venne
Carnival Parade (Vastenavondoptocht)
Collection Museum Boijmans van
Beuningen, Rotterdam

103
Peter Flötner
Fool, c.1530
The British Museum, London
© British Museum

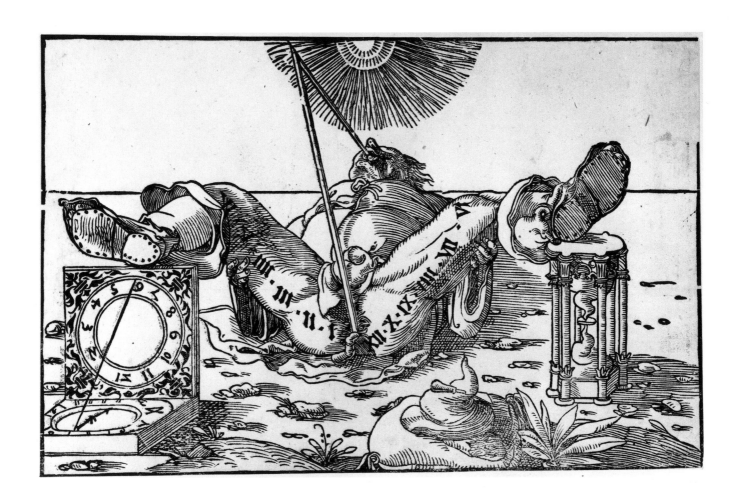

102
Peter Flötner
A Human Sundial, c.1530
The British Museum, London
© British Museum

By the 1550s, when Pieter Bruegel (1525–69) began to create first prints, and then paintings, he was heir to a rich literature and imagery of folly. Bakhtin writes of 'a millennium of folk humour breaking into Renaissance literature', first in Rabelais's *Gargantua and Pantagruel* (1532–52), then in Cervantes. Bruegel had a comparable role, transmitting the medieval world of laughter into a sophisticated and mostly classicizing visual culture. Hieronymus Bosch (*c*.1450 – *c*.1516) made several variants on the Ship of Fools theme. Under the inn-sign of that same 'Blue Boat' depicted in Bruegel's *Carnival and Lent*, mummers perform the play of *Orson and Valentin* – a tale which also provides the theme for his only woodcut, one of the most vivid representations of the 'Wild Man', the traditional Carnival figure still so important today in many Alpine regions. And Bruegel's paired *Kitchens* embody again the conflict of Lent and Carnival. Awash in sausages, the fat cooks nevertheless evict the alien starveling: 'Out of there, Meagreman / However hungry you may be / This is the fat kitchen / And you will not be served'. In retrospect, the mid-sixteenth century was the highpoint of the carnivalesque. Following the Council of Trent (from 1564 onwards), *Eulenspiegel* and similar joke books were suppressed, their publishers imprisoned. The imagery of laughter became less visible.

● ● ●

46
After Bruegel
Orson and Valentin, c.1566
The British Museum, London
© British Museum

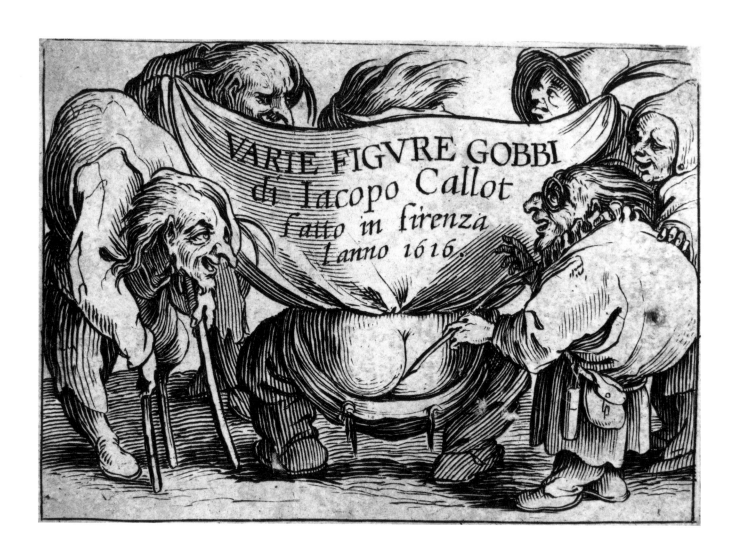

94
Jacques Callot
Title plate from *I Gobbi*, 1616
The British Museum, London
© British Museum

In Florence in 1616 the twenty-four-year-old Jacques Callot (1592–1635) signed a splendid etched plate, in which a group of laughing *gobbi* (hunchbacks) raise up one of their companion's shirts, to be inscribed with the title – thus exposing his bare bottom beneath. These tiny, skipping, brilliantly crisp and energetic *gobbi* are the heirs to Flötner's dwarf-fool, and to the medieval *grylli* – joyous celebrations of deformity. They may also reflect the troupe of dwarves known to have performed burlesque ballets at the Medici court. Callot's father was a highly-placed court functionary at Nancy when the boy fled south. In Florence he embraced the rich theatrical tradition known as *commedia dell'arte*, which claimed its origins partly in the ancient masked comedians, retrieving an archaic imagery for the modern European stage. The name of *commedia*'s most famous character, Harlequin, is derived from the Erl-King, leader of the Wild Hunt, the army of the dead (see page 62). Callot's *Balli di Sfessania* recreate the mimed dialogues between stock types. We see 'The Captain' (a ragged posturing Bardolf) assaulted with a gigantic enema; or standing insolently, his sword transformed into a slimline erection, while the contorted 'Cucuba' hurls abuse. Between them we glimpse a distant carnivalesque streetlife – a boy on stilts in a ring of dancers, or a figure riding backwards on an ass, propelled by bellows. Printed in very large numbers, etchings like these were important in disseminating the laughter of Carnival through the succeeding centuries.

● ● ●

97
Jacques Callot
Plate from *Balli di Sfessania*, c.1621/22,
(detail)
The British Museum, London

Callot's vision retains a kind of impersonality; it embodies popular experience, a commonality that seems out of reach to most subsequent artists. When the imagery of the carnivalesque returns after 1700, it is often as a phantasmagoria, threatening the individual. In his fascinating print of 1773, *Omnes Videntes Me Beriserunt Me* (*All Looking at me, Laugh at me*), the Bordeaux artist J.L. Foulquier (1744–89) shows us the mask as the paranoid fantasy of the individual (see p. 56). The woebegone little wayfarer under his great hat, who lays aside his stick to seat himself sadly on the low parapet, is overwhelmed by a carnivalesque crowd much more vivid than himself. Among the masks of smiling cruelty, we make out dowager and abbé, bird-of-prey and horned beast, all led by a frock-coated wolf / boar with a terrible tusk. And closest to him, a bespectacled bottom does its business. In carnival language the bottom is 'the back of the face', the face 'turned inside out'. But this is no joyous inversion. We know almost nothing of Foulquier, but in this great image he anticipates the tormenting and hallucinatory masks of Goya, Ensor and Beckmann.

Very Tragical Mirth (1750–1880)

The caricatural vein in Italian Baroque artists, especially striking in Guercino (1591–1666), stands to their 'serious' production rather as Carnival to the rest of the year. *Man Frightened by a Monster* enters a region of the imagination that could not be accommodated within the grand rhetoric of his official style. The encounter is compelling and powerful, but only the licence of a comic genre allows it to take place. This comic residue surfaces also in the work of Giambattista Tiepolo (1696–1770) when he collects individual figures in contemporary dress, each rendered plausible in limpid pen-and-wash, yet subtly distorted; they become solitary freaks, monsters of self-regard. His Pulcinella compositions were made in connection with the Verona Carnival, when the masked, hunchbacked figures in their white pyjamas multiplied in the streets and consumed the Friday ritual feast of gnocchi (the *Venerdi Gnoccholare*). Gnocchi were cooked in a tall conical pot, which becomes the distinctive tapering hat of the entire Pulcinella tribe whose members are sometimes conceived by Tiepolo as urban satyrs; idle and feckless, but usually with a melancholy

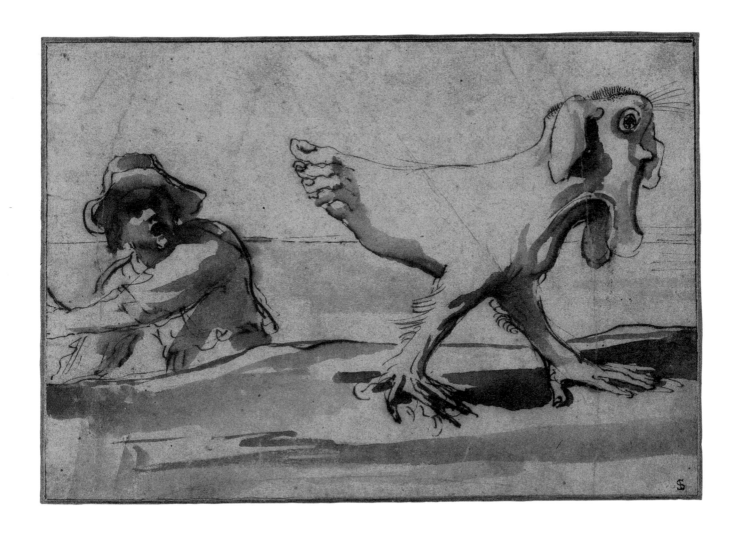

116
Il Guercino (Giovanni Francesco Barbieri)
Man Frightened by a Monster, c.1620
Board of Trustees of the National
Museums and Galleries on Merseyside
(Walker Art Gallery, Liverpool)

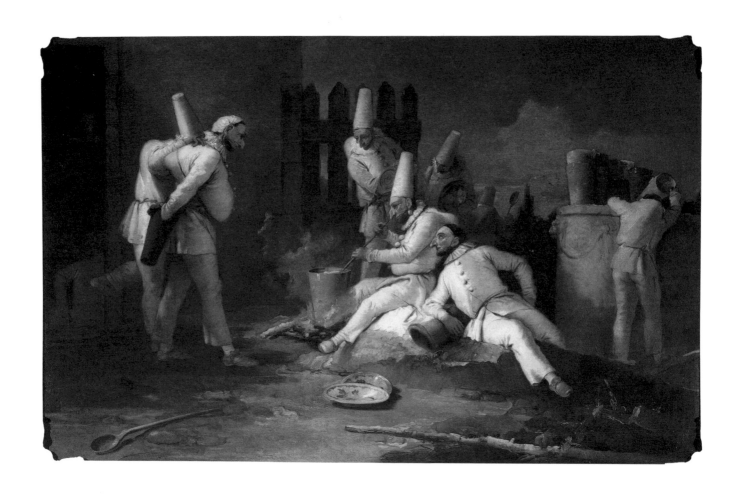

60

Giambattista Tiepolo
Pulcinella's Kitchen, c.1735
Trustees of the Leeds Castle Foundation
Photograph: Angelo Hornak
© Leeds Castle Foundation, Maidstone

grandeur, as we see in the marginal community of *Pulcinella's Kitchen* (c.1735). Gnocchi are an inherently comic food, because they are notoriously indigestible; Giambattista's Pulcinellas often suffer racked sleep and painful excretion. In the Courtauld drawing, however, we see a smiling and particularly well-fed specimen, whose swollen contour is beautifully held within the sheet; he is well on the way to becoming the homicidal glove-puppet, 'Mister Punch'.

When, some sixty years later, Giambattista's son Domenico (1727–1804) took up the Pulcinella theme again, it was in an entirely different context. In Venice, the revolutionary enlightenment was bent on suppressing all the imagery of the *commedia dell'arte*; as the French-sympathizing intellectual Antonio Piazza wrote in 1797:

> 'These inane and wretched improvised comedies, which stupefy the ignorant audience without enlightening or correcting them, should be outlawed.'[15]

For the elderly Domenico to invoke Pulcinella, first in the frescoes for his own villa, and then, at seventy-five, in his sequence of 104 drawings, amounted to an act of private dissent. No likely patron has been identified, and the *Life of Punchinello* should probably be seen as his solitary affirmation of the power of a free 'carnivalesque' imagination.[16] In *The Birth of Punchinello*, (see p. 24), the infant bursts from the egg already fully masked-and-pyjama'd, to be greeted rapturously by his fellows; a crone or granny clasps her hands, and recoils at the prodigy. An illustrious poultry-ancestor looks down from the wall. The delicate pencil underdrawing is still visible, overlaid by a flickering, hectic ink line that unites rushes and feathers, gesticulating hands and fluttering pyjamas, a wobbling ladder and even wobbly bricks. Crucial to the design is the diagonal that divides shadow from light; the tone ranges from the purest pyjama-white of the paper, through many varieties of reddish-brown wash, to the dense opacity of the beaked noses. The *Giant Crab* belongs to a much later point in the cycle, a wanderings-of-Punchinello-in-exile. Domenico makes a brilliant compositional pun – the double-jointed figures echoing the articulation of the crab's claws; the stranded, groping monster corresponding to the lost helplessness of the figures. By 1802, the Republic of Venice had ceased to exist, betrayed by revolutionary

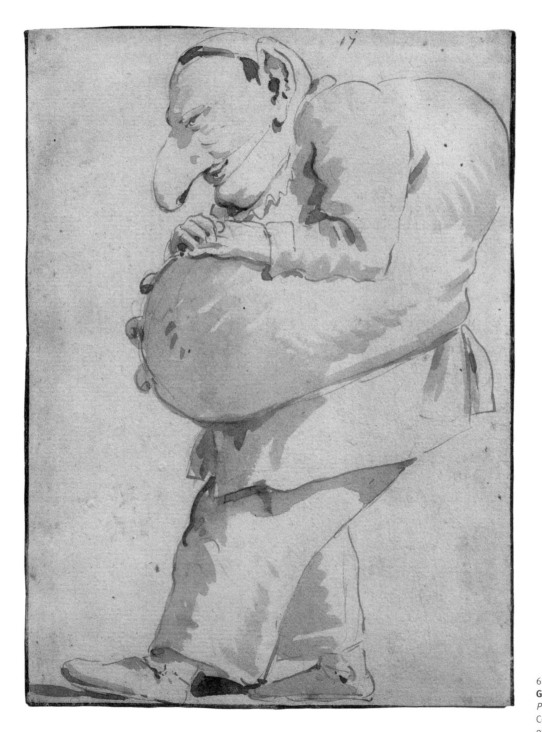

61
Giambattista Tiepolo
Pulcinella, c.1743
Courtauld Gallery, Courtauld Institute
of Art, D.1952.RW.2475
The Courtauld Gallery, London

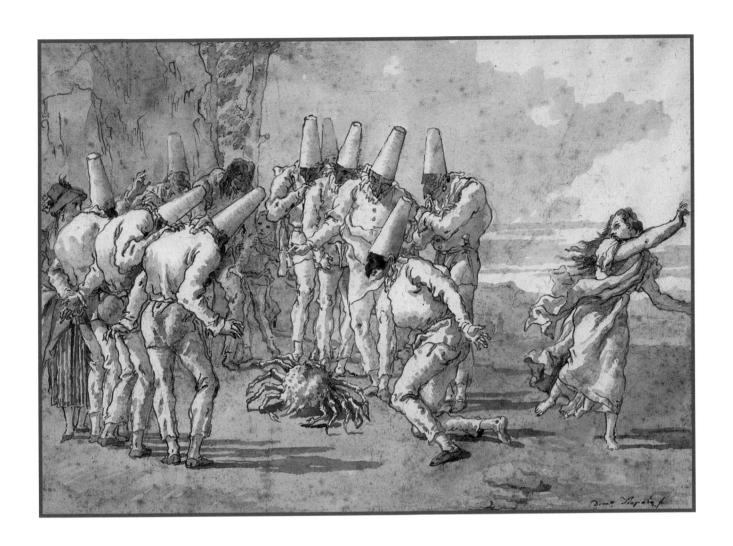

59
Domenico Tiepolo
Punchinellos with a Giant Crab, 1802
Executors of the late Sir Brinsley Ford

France and sold to Austria. Domenico, like his younger contemporaries Gillray and Goya, worked in a world divided between two opposed conventions: the discredited roccoco he had inherited from his father; and neo-classicism, with its reformist moralizing zeal. In the tender absurdity of Pulcinella, Domenico found a serio-comic theme that evaded both rhetorics, and released an unparalleled late flowering.

● ● ●

Three years later, the English caricaturist James Gillray (1756–1815) presents the Napoleonic Wars as a theatre-of-the-world, the proscenium invaded by orchestra and audience all rising up in crazy hubbub, conjured by an exceptionally wild and reckless line; and on the reverse, he jots down a long list with the same furious speed, his words hardly able to keep pace with images and ideas. As we scan the four columns, some groupings appear: references to specific London topography ('A Conversation in Soho Square', 'Taking Refreshment in Piccadilly', 'Going to Christie's on a Frosty Morn'); theatre and art-world allusions; as well as topical and scandalous events. More enigmatic, at the top of the central column, is 'Devil on Two Sticks': the title of a novel by the French writer René Lesage, in which the crippled but airborne devil Asmodeus lifts the roofs off Madrid. What Gillray's list evokes is a *disclosure* of this kind: his own city unmasked by the caricaturist's X-ray eye and spread out like an enormous cutaway panorama. The list is headed: 'A series of subjects in ye year 1805, worthy of ye talents of British Artists.' The new British Institution had just been announced, and Gillray's list ridicules the narrow subject-matter permitted under the 'Triumph of ye arts polite'.

As a young man, Gillray had attempted to go straight as a stipple-engraver; his return to caricature, after three years of bruising failure, was pursued 'with a vengeance'. He rejected neo-classical composition for a kind of pseudo-baroque, derived partly from Henry Fuseli – what Gillray called 'his mock-sublime mad taste'; he achieved a displaced history-painting, but in the burlesque mode. His beautiful little oil painting of 1800, *Voltaire Instructing the Infant Jacobinism*, proves how atmospheric his handling could be in that medium. The scene is set in hell, with the ever-smiling *philosophe* enthroned, surrounded by murky ghouls, and

10
James Gillray
Verso: *List of subjects 'worthy of ye talents of British artists'*
Private collection, London

10
James Gillray
Recto: *Theatre of the World: The
Revolutionary Wars*, 1805
Private collection, London

preparing his new radical devil for entry to the upper realms. Hogarth has often been praised, by contrast with Gillray, for his 'moral discrimination'; he always preserves a certain decorum, even in subjects as coarse as *The Political Clyster* (1726) where Gulliver's bottom suffers the indignity of a colossal enema. Gillray is fuelled by some far more irrational power, closer to the roots of caricature: infantile rage, mania, fear, mad abuse. Among his predecessors, the weird figures etched in the 1770s by William Austin (1721–1820) remain too little known. An accomplished drawing master in the polite mode, he here invents a world of grandly infantile grotesques, filling the page with Carnival presences. Mrs Fat processes with Mr Thin to the Pantheon, 'in their natural masks'; we recognize in *The Macaroni Assmatch* the Carnival accomplishment of backwards donkey-riding, and the smiling protagonist even procures a fart from his ragged steed. *The Anatomist Overtaken by the Watch* shows a corpse-snatcher (who may be the famous physician Dr William Hunter) dropping the doll-like 'Miss Watts' from his hamper.

Gillray's drawings are often more extreme than his prints. There is no etched parallel to the visceral line of *Curing John Bull of his Canine Appetite*, with William Pitt as multi-armed, mantis-like toothpuller, his thinness contrasted to his victim's bulkiness, an enema simultaneously enacted below. In *The Card Table*, Gillray improvises a whole room full of rapacious monsters, each individuated in separate, unpredictable marks; freest of all are the squiggle-heads at the front. (It is revealing to compare Thomas Rowlandson's masterly *Exhibition Stare-Case* (see p. 77) where everyone is homogenized into the same roly-poly type.) Pierre Schneider observed that caricature 'has something in common with both script and images . . . It is speed which turns an image into a character.'[17] Several of Gillray's later drawings are made at breakneck speed and spattered with words – a 'brainstorming' which results in a kind of drawing-writing. *The Invisible Girl* was a perennial fairground character. (Her booth turns up in the 'Bartholomew Fair' section of Wordsworth's 1805 *The Prelude*, as well as in the works of the German storyteller E.T.A. Hoffmann.)[18] She is a modern oracle, whose insidious voice we 'see' emerging from the globe through trumpets, to torment John Bull:

> 'I'm a little invisible girl that knows all . . . that knows everything Johnny.
> I can tell you a story. Take care of your wife, Johnny'

● ● ●

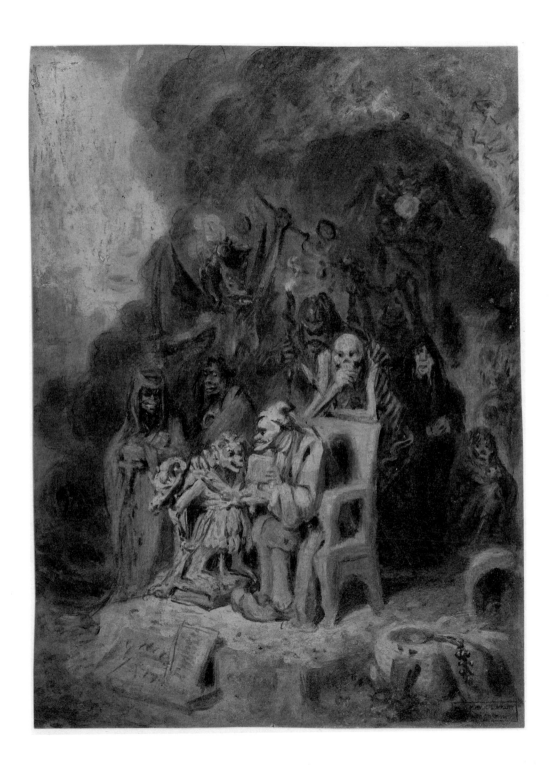

9
James Gillray
*Voltaire Instructing the Infant
Jacobinism*, 1800
Print Collection, Miriam and
Ira D. Wallach Division of Art,
Prints, and Photographs, The
New York Public Library, Astor,
Lenox and Tilden Foundations

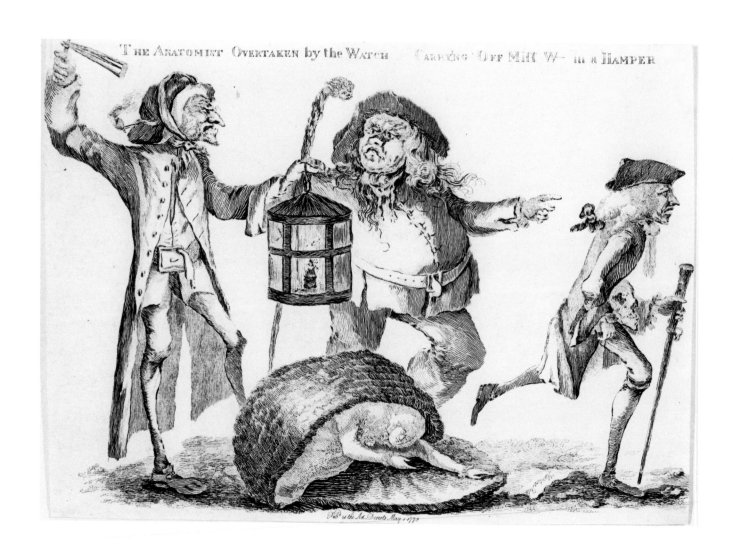

THE ANATOMIST OVERTAKEN by the WATCH CARRYING OFF MISS W— in a HAMPER

87
William Austin
The Anatomist Overtaken by the Watch,
1773
Private collection, London

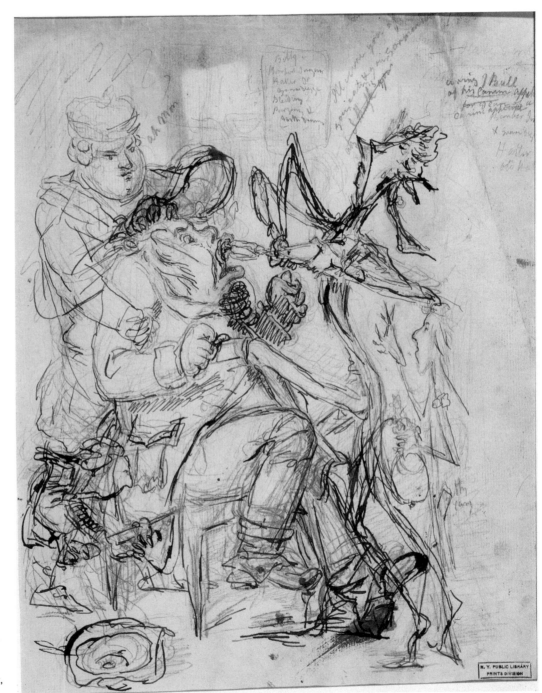

107
James Gillray
*Curing John Bull of his
Canine Appetite (Pitt pulling
out John Bull's teeth)*, 1796
Print Collection, Miriam and
Ira D. Wallach Division of Art,
Prints, and Photographs,
The New York Public Library,
Astor, Lenox and Tilden
Foundations

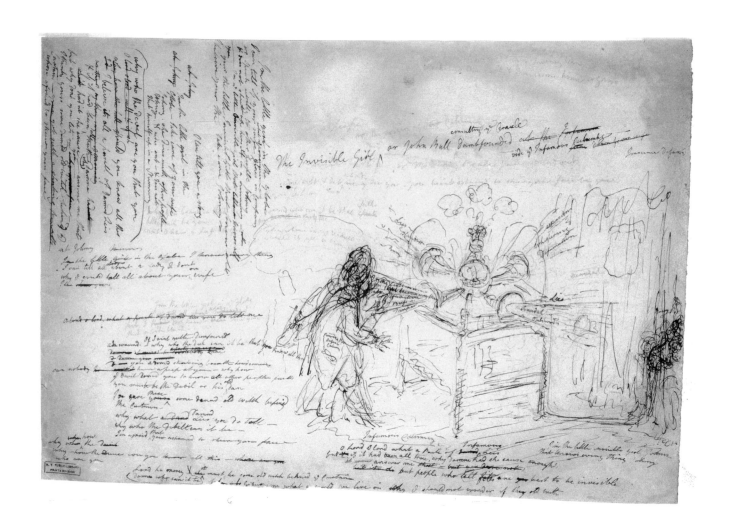

51
James Gillray
*The Invisible Girl (The Little Girl
in the Globe)*, after 1800
Print Collection, Miriam and
Ira D. Wallach Division of Art, Prints, and
Photographs, The New York Public Library,
Astor, Lenox and Tilden Foundations

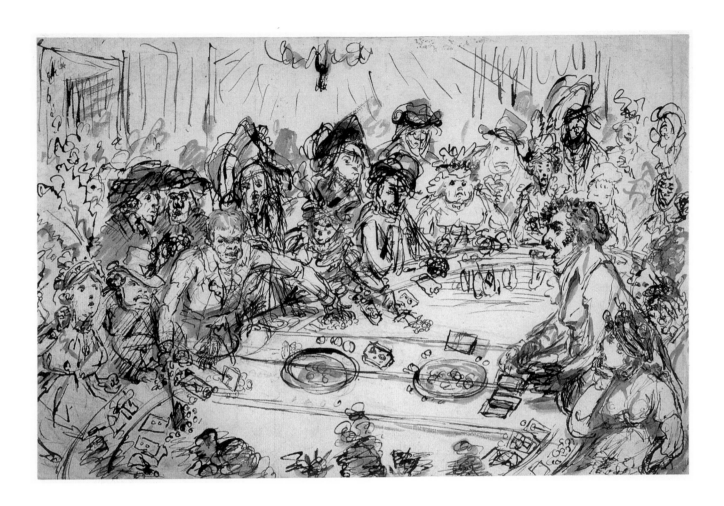

8
James Gillray
The Card Table (Aristocrats Playing Faro),
c.1800
The British Museum, London
© British Museum

The art of Goya (1746–1828) is the fusion and culmination of all the traditions outlined above. The publication of *Los Caprichos* was delayed to Ash Wednesday of 1799 – that is, to the day after the last Carnival of the eighteenth century; and allusions to Carnival become ever-stronger in his work thereafter.[19] The greatest artist of the nineteenth century, late Goya was essentially a discovery of the twentieth, and much remains still to be elucidated. When Goya first came to Madrid, Giambattista Tiepolo was painting at the Royal Palace, assisted by Domenico, but already challenged by supporters of the neo-classical painter Anton Raffael Mengs. Juliet Wilson-Bareau has recently made clear that when Domenico returned to Venice after his father's death, the young Goya may have accompanied him 'at least as far as Genoa' – a journey of several weeks. Goya probably visited the older artist in Venice, and there is strong circumstantial evidence that they kept in touch: when Domenico died in 1804, he was one of only twenty-seven people to own a copy of *Los Caprichos*.

By the 1790s Goya was familiar with several Gillray caricatures. He was opposed to neo-classical convention; we hear of his membership of a burlesque secret society, the *Acalafilos* (lovers of ugliness). He had also become aware of the works by Bosch in the Royal Collections, and the generic title given to those astonishing works, *Disparates* (absurdities), would be adopted for his own final series of aquatints, published long after his death. One might say that the folly imagery associated with Carnival supplied Goya with a 'universal idiom', to use his own phrase from the frontispiece to *Los Caprichos*.

Soon after completing his 'Black Paintings', Goya went into exile in Bordeaux. His discovery of the lithographic crayon, when already in his seventies, resulted in a line that was always a little 'out of control', a quasi-automatic mark-making as figures appear under his hand. The crayon drawings of the Bordeaux albums break entirely new ground. In *Comical Discovery*, the mask proliferates, and the multitude of disembodied heads creates very dark associations: the prisoners in Plato's cave; perhaps of holocaust or massacre. And yet, as with those terrible heaps in the late paintings of Philip Guston, the mood remains resolutely comic. Pierre Gassier wonders if this drawing may be:

> 'a caricatural evocation of a crowd, possibly seen under a circus tent in
> Bordeaux in 1826 – any crowd being easily transformed, in the eyes of
> a rationalist, into an infernal vision.'[20]

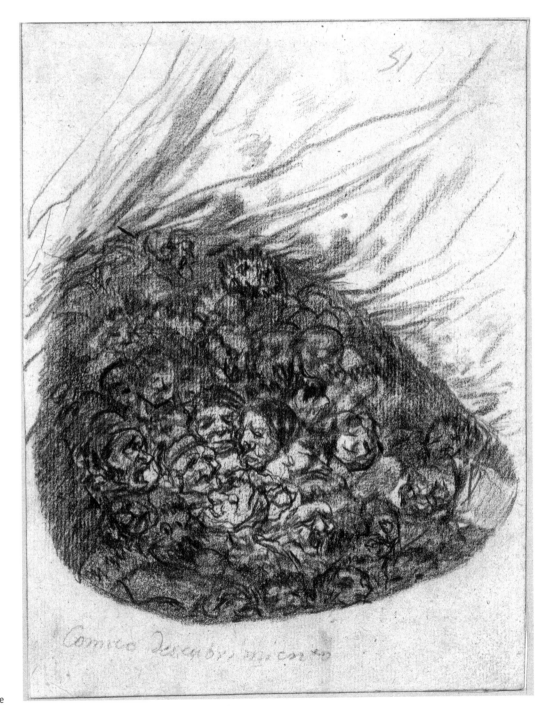

80
Francisco Goya
Comical Discovery (*Comico descubrimiento*), *c*.1824–25
Lent by the Syndics of the Fitzwilliam Museum, Cambridge
Photograph copyright of The Fitzwilliam Museum, University of Cambridge

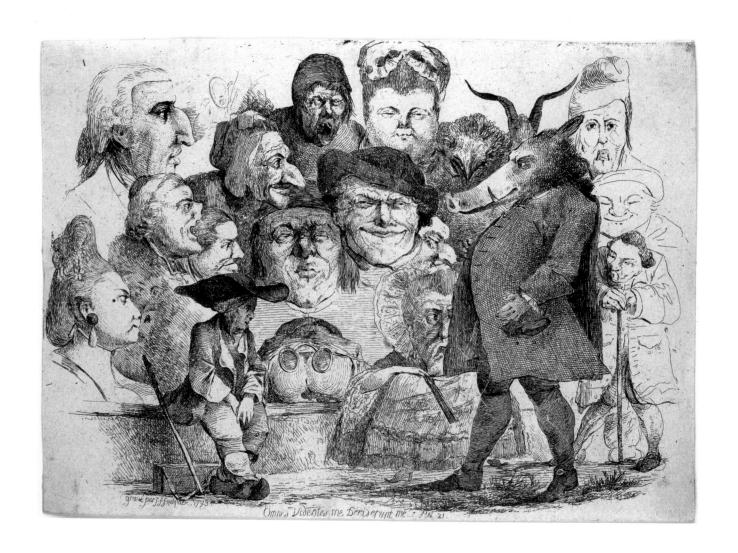

76
J.F. Foulquier
*All Looking at me, Laugh
at me (Omnes Videntes
Me Beriserunt Me)*, 1773
Andrew Edmunds, London

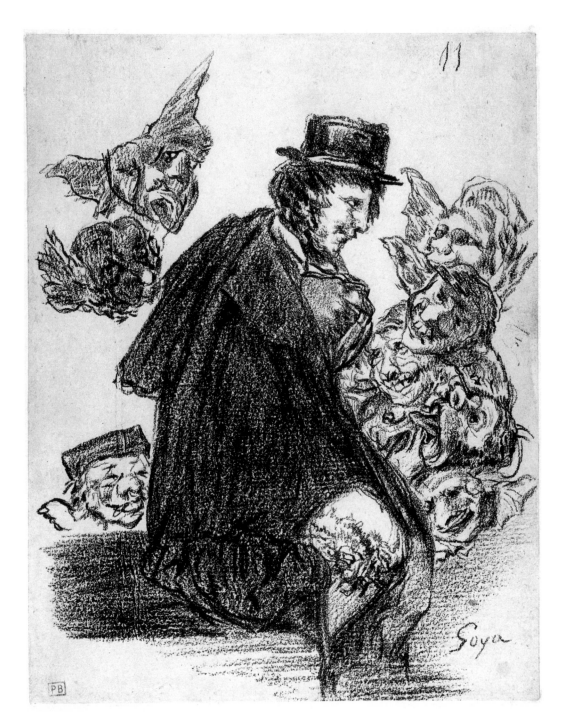

81
After Goya
Seated Man with Winged Heads (*Man Beset by Monsters*), c.1827
The British Museum, London
© British Museum

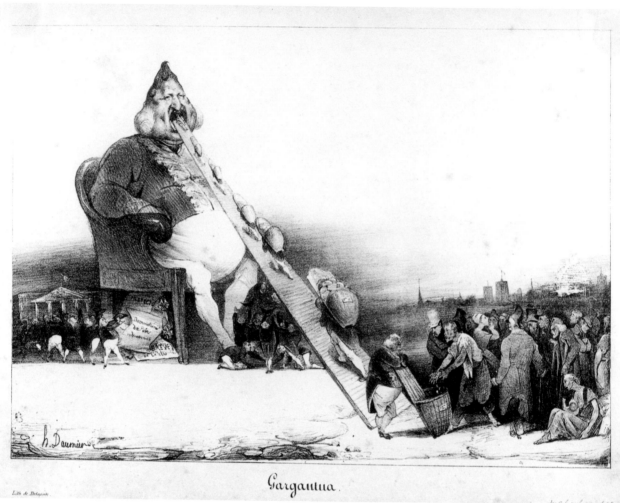

Gargantua.

100
Honoré Daumier
Gargantua, 1831
Collection John Wardroper

Man Beset by Monsters is probably a faithful copy from an even later album-drawing. It recalls the famous *Dream of Reason* frontispiece from *Los Caprichos* of twenty-eight years earlier; but now, instead of bats, foolishly grinning winged masks flap about him, and he smiles feebly back. The affinity to Foulquier's phantasmagoria, drawn in Bordeaux half a century before, is too striking to go unmentioned.

• • •

The achievement of Honoré Daumier (1808–79) begins with *Gargantua* and ends in *Quixote*. His art challenged the increasingly rigid divisions in French culture between High and Low; it was nourished by popular shows and fairground performers. His greatest achievements as a painter – the *Dangling Man* in Ottawa or the *Ecce Homo* in Essen – are not in the least comic. But as a twenty-three-year-old, in 1831, he recreated the citizen-king Louis-Phillippe as Rabelais's carnival giant Gargantua, relieving himself in the midst of the Place de la Concorde on a *chaise percée*. He could draw upon an earlier popular imagery of Gargantua as a glutton at table, with little figures bringing endless provisions. (Note, on the left, the one who has lowered his trousers to surprise the monster with an unexpected delicacy.) He would also have known Gillray's splendid allegory of Pitt as a gigantic anti-Midas, transmuting gold into the spew and excrement of paper money. But Daumier's lithograph is even more monumental, and the sense of waste – of the fruits of toil being consumed by a pear-shaped fool, only to become worthless honours – is far more poignant. Daumier was fined 500 francs and condemned to six months in prison, for 'rousing hatred and contempt for the King's government'; and indeed, as an attack on the monarchical system the work has lost none of its force.

• • •

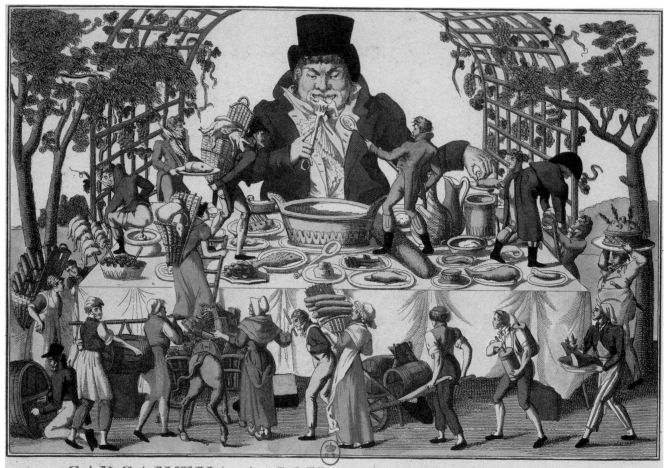

GARGANTUA A SON GRAND COUVERT.

A Paris chez Basset, Md. d'Estampes, rue St. Jacques au coin de celle des Mathurins, No. 64. Déposée a la Bibliothèque Imperiale

84
Anon, published by Basset
Gargantua's Feast (*Gargantua à son
grand couvert*), 1810–15
Cabinet des Estampes, Bibliothèque
nationale de France, Paris

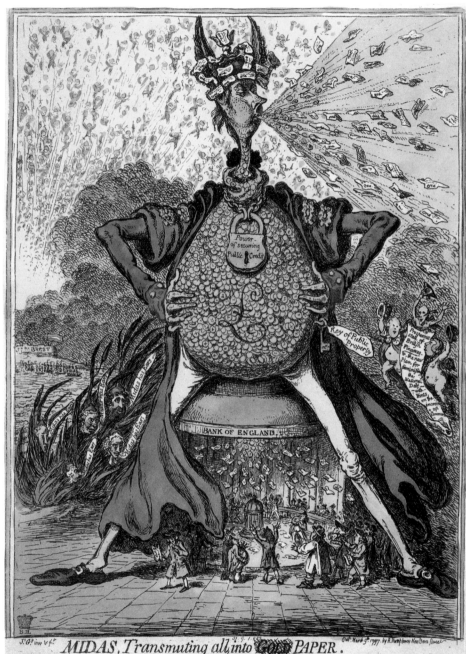

MIDAS, *Transmuting all into GOLD PAPER.*

History of Midas,—— *The great Midas having dedicated himself to Bacchus, obtains from that Deity, the Power of changing all he Touched. Apollo fixed Asses Ears upon his head, for his Ignorance —— & although he tried to hide his disgrace with a Regal Cap, yet the very Sedges which from the Mud of the Pactolus, whisper'd out his Infamy, whenever they were agitated by the Wind from the opposite Shore.*

108
James Gillray
Midas, 1797
The British Museum, London
© British Museum

From Ensor to Ourselves (since 1880)

Although the Paris Carnival was, after Haussmann's transformation of the streets into boulevards, tamed into a civic and military parade, something of its burlesque poetry survived into the late nineteenth century in the small circuses and cabarets. Lautrec's affectionate lithograph of a cavalcade at the Moulin Rouge shows the almost bare-breasted women on their ass-steeds, surrounded by clowns and grotesques, making the round of the little arena with a defiant majesty – the last vestiges of the Bacchanalia.

In James Ensor's *The Infernal Cortège* of a few years earlier, the archaic identity of Carnival is made even more explicit. In a famous text of 1091, the priest Goshelin describes the procession he encountered in the early hours of 1 January. It was led by a giant rider, the Erl-King; the army marching behind him included men in animal-skins bearing kitchen utensils, Ethiopians carrying a gibbet; women riding red-hot saddles [21] Ensor's own *diableries* are embodied in a bitten line of unmatched, spiky wit and graffiti-like autonomy, as in the scorings struck out against the sky beside the crescent moon. Pitchforks, plumes, the long hair of a Lady Godiva – all participate in the same abbreviated sign language; closer scrutiny reveals a lobster, several scraggy birds, a fish; as well as the wonderful comic congestions at both the lower corners. More than any artist before or since, Ensor in his brief flowering spoke the language of Carnival. He lived from birth above his mother's Carnival shop. Encouraged by his English father he became acquainted early with Gillray and the caricature genre, read Rabelais in his teens and drew from the Goyas in Lille. Ensor's etching *Combat des Pouilleux (Rumpus of the Down-and-outs)* is a knockabout masterpiece, and the mayhem is in the marks. A room has been invaded by utter anarchy, with enema-squirters bursting through the windows, projectile vomit at lower right and the gendarmes already on their way. A year later Ensor would embark on his fourteen-foot *Entry of Christ into Brussels*, where Christ is a Carnival-King seated on a donkey, almost lost in the masked mob rampaging towards us. Within two years, the vision had faded. The fugitive little *Scène Carnivalesque* of *c.*1890 retains Ensor's beauty of handling, but any social or satirical significance has disappeared, leaving the masks floating in a void.

● ● ●

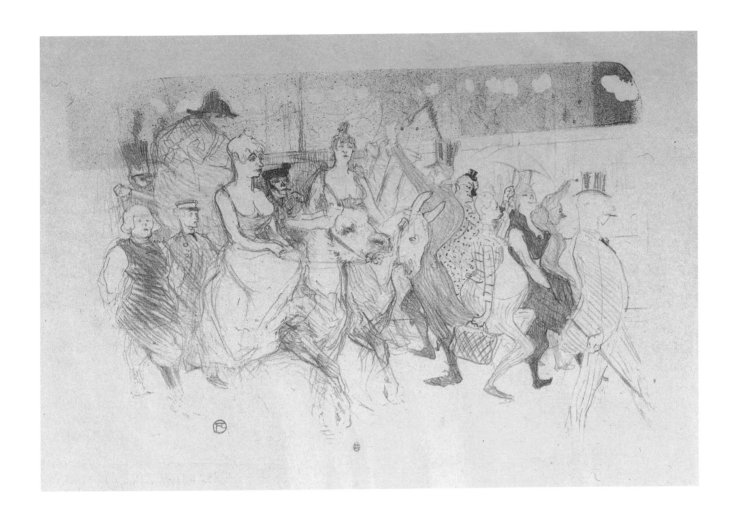

20
Henri de Toulouse Lautrec
A Cavalcade at the Moulin Rouge (*Une Redoute
au Moulin Rouge*), 1893
Cabinet des Estampes, Bibliothèque nationale
de France, Paris

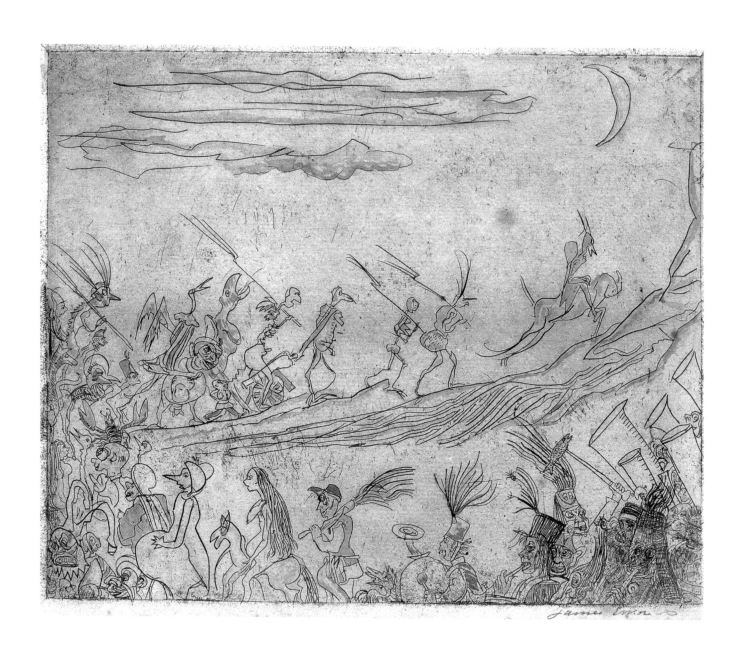

4
James Ensor
The Infernal Cortège, 1887
Museum voor Schone Kunsten, Gent
© DACS 2000

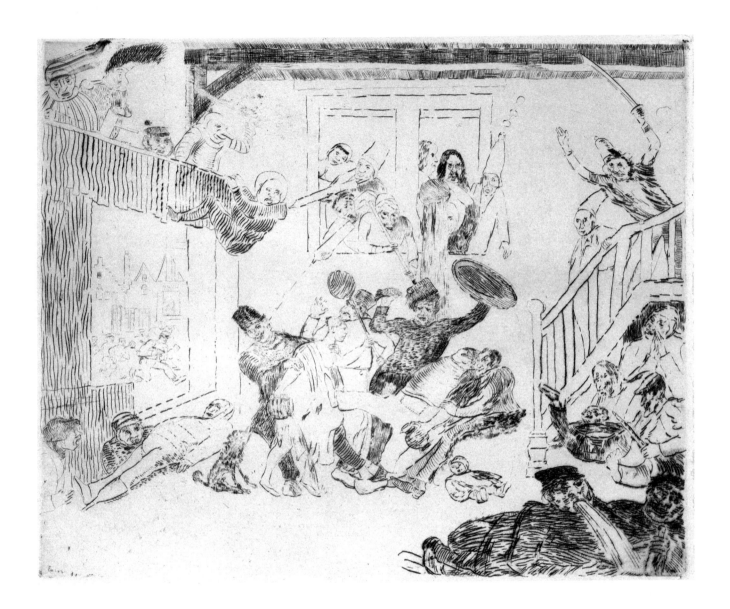

101
James Ensor
Battle of the Down-and-outs
(*Combat des Pouilleux*), 1888
Museum voor Schone Kunsten, Gent
© DACS 2000

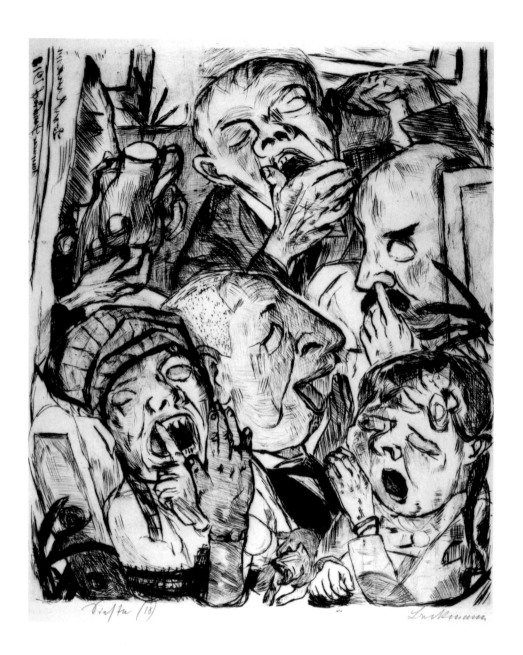

70
Max Beckmann
The Yawners, 1918
The British Museum, London
© British Museum
© DACS 2000

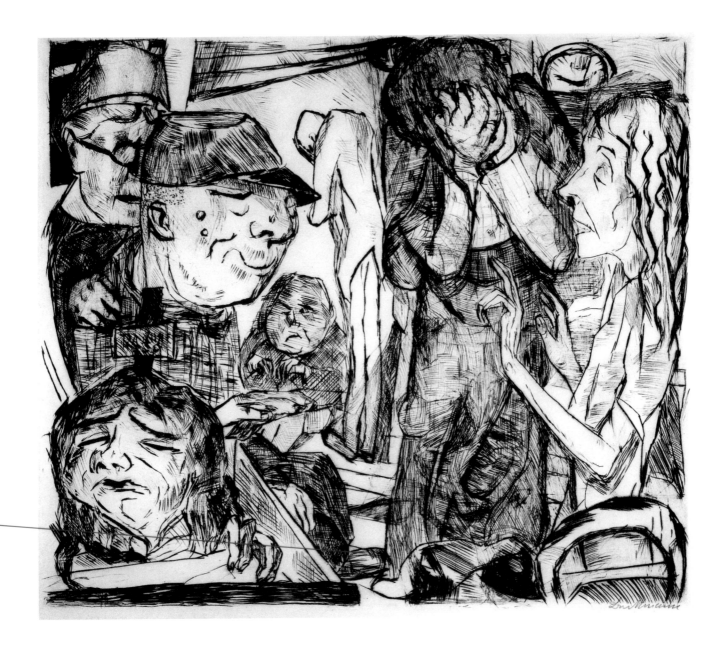

69
Max Beckmann
Madhouse, 1918
The British Museum, London
© British Museum
© DACS 2000

For artists trained after 1880, the contrary to carnivalesque was no longer neo-classicism, but the essentially formalist and secular aesthetic of French modernism. Ensor painted his *Entry* in deliberate refutation of Georges Seurat's *Un Dimanche d'été à la Grande-Jatte*, his 'dry and repellent' procedures. When Max Beckmann (1884–1950) arrived in Frankfurt in the middle of the First World War, after a terrible breakdown, and having abandoned his wife and child, he found himself repudiating the academic impressionism of his earlier work. His new identification with German medieval masters coincided with his increasing interest in the esoteric; and in the South German Carnival, he discovered the masks of 'Fastnacht'. The Tate's *Fastnacht (Carnival)* was one of the few paintings completed in this period, though it ended up drier and more inert in handling than the British Museum's beautiful first pencil study of 1920 had promised. But these were the years of Beckmann's greatest achievement in graphic art. He came to see his own life with the irony of Carnival, as masquerade and pageant; he is the fairground barker who summons us to 'Circus Beckmann' – 'Full satisfaction guaranteed, or else your money back'.[22] His imagery took on a Carnival crowding. In each of four drypoints from the portfolio *Gesichter (Faces)* which Beckmann originally entitled *Theatre of the World*, the mask – whether the midnight couple of *Theatre*, the voyeurs behind the sofa of *The Brothel*, or the terrible array of open-mouthed *Yawners* – plays the key role. In *Madhouse*, inconsolable grieving figures are flanked by the masks of the blindly indifferent. The artistic lineage of such an image is clear; writing to its publisher, Reinhard Piper, Beckmann cites: 'Brueghel, Hogarth, Goya. All three have the metaphysical in the Objective. That is also my goal.'[23]

●　●　●

In the New York of the early 1960s, Red Grooms (b.1937) found himself standing apart from his Pop contemporaries. His art, like theirs, alluded to popular imagery:

> 'but I liked it to have a warmness to it. I didn't grasp giving it a sterile look. Pop was all about being cool, and I knew I didn't fit in with that.'[24]

54
Red Grooms
Video still from *Fat Feet*, 1966
Courtesy the artist
© The artist 2000

115
Red Grooms
Tattoo Parlor, 1998
Private collection, Connecticut
© ARS, NY and DACS, London 2000

13
Red Grooms
At the Stroke of Midnight, 1976–92
Saskia Grooms
© ARS, NY and DACS, London 2000

Grooms had participated in the earliest, anarchic 'Happenings'; his milieu included
the poet Frank O'Hara, the dance critic Edwin Denby and the film-maker Rudy
Burckhardt, all celebrants of the city.[25] But Grooms also had a long-standing interest
in the achievements of 'Outsiders'; and he shared with Burckhardt a love for the
primitive cinema of Georges Méliès. *Fat Feet* (1966) comes out of that early 'vision
of doing clownlike magic things',[26] of returning cinema to its childhood. In the spirit
of Facteur Cheval constructing his *Palais Idéal*,[27] Grooms set out to rebuild New
York as a handmade, carnivalesque world. Every element of urban experience – a
panorama of smoking chimneys, a garbage-lorry, a revolving door – is improvised
anew; and the live actors clunk about the set, transformed by enormous foot-
extensions into Carnival types: Cop, Witch, Hoodlum, Hobo A few years later,
Grooms and Mimi Gross assembled a team to build together the astounding 'sculpto-
pictorama' *Ruckus Manhattan*. One lurches through a sprung-floored subway-car past
seated grotesques, and crosses a phantasmagoric Brooklyn Bridge. The gouache
At the Stroke of Midnight was begun that same year, in what Grooms calls his
'proletarian' or 'Discount Store' manner.

• • •

For most artists working in London or New York over the past fifty years, the
lineage outlined above – 'the grotesque canon' – has been entirely divorced from
any experience of actual Carnival. Philip Guston (1913–80) had made direct reference
to Domenico Tiepolo's white-hatted Punchinello, in his early masterpiece *If This Be
Not I* (1945); and he had also been fascinated by Beckmann. But it was only after
more than twenty years as an abstract painter that Guston suddenly switched to
an epic-scaled carnivalesque at the end of the 1960s, and emerged in his hooded
Klansmen, his heaps and smoking-and-drinking selves as the great serio-comic
painter of the second half of the century. The comic-strip visionary Robert Crumb
felt the affinity:

> 'It was as though we had both tapped into this great grungy
> unconscious – all the unconscious imagery of lower middle
> class America' [28]

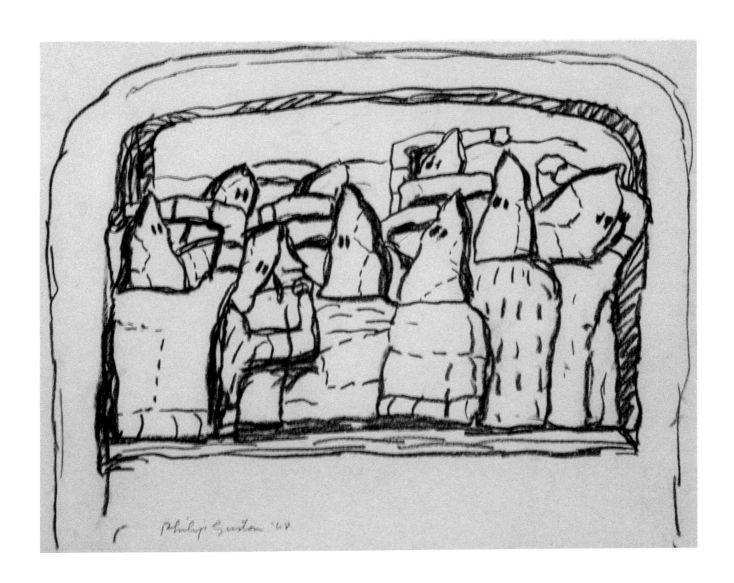

82
Philip Guston
Untitled (Klansmen), 1968
Alexander Walker Collection, London,
courtesy the Timothy Taylor Gallery
© Estate of the artist

Just as Carnival challenges the narrow authority of Lent, so carnivalesque imagery
has acted as a corrective to each successive hegemony in the visual arts; breaking
in upon the prevailing aesthetic norm – classical, neo-classical, or the cool American
formalism of the 1960s (whether of the Greenbergian or the Warhol variety) –
rather as laughter breaks in upon the body. Such imagery enacts a loss of control,
a temporary hiatus, that restores and heals. In the 1980s, as Guston's achievement
began to be recognized and many of the artists represented here took on a new
currency, Carnival values briefly threatened to become the norm, the 'mainstream'.
But today our prevailing art climate has changed once again – from warm-and-
wet to cool-and-dry. If Bakhtin is still invoked, and 'carnivalesque' embraced as
a condition to which every post-modern might aspire, it is nearly always as a
willed strategy of 'transgression' and 'the abject'. It seems important to recall
that Bakhtin's vision was of a victory of laughter over fear. The nexus of imagery
proposed here – crowd, upside-down, mask, grotesque – remains a perennial
resource for artists of all media, by which the freedom of foolishness can be
reasserted for a new millennium. 'Thus even in our time,' writes Bakhtin:

> 'those genres that have a connection, however remote, within the tradition
> of the serio-comical preserve in themselves the carnivalistic leaven or
> ferment . . . the sensitive ear will always catch even the most distant
> echoes of a carnival sense of the world.'[29]

A Carnival Sense of the World
Footnotes

1 In Athens, the end-of-winter festival of the Anthesaria was a time of disruption and reversal. Its procession was led by a figure masked as Dionysus (the god who 'turns things inside-out') wearing a phallus on his forehead. See Herbert Hoffmann, *Sotades*, Oxford, 1997.

2 Mikhail Bakhtin, *Problems of Dostoevsky's Poetics*, Manchester, 1984, p. 107.

3 In Vitebsk in 1920 Bakhtin became friendly with Marc Chagall, who would embark soon after on his superb series of 102 drypoints to *Dead Souls*.

4 It is now known that Bakhtin plagiarized long extracts from Cassirer and others, in *Rabelais and his World*.

5 Mikhail Bakhtin, *Rabelais and his World*, M.I.T., 1968, see especially pp. 4–8 and p. 218.

6 *ibid*. p. 29

7 See, for example, the copy after a lost Bosch, *The Concert in the Egg*, now in Lille.

8 Mikhail Bakhtin, *Rabelais and his World*, p. 211

9 E.K. Chambers, *The Medieval Stage*, Vol. I, Oxford, 1954, p. 294.

10 Michael Camille, *Image on the Edge*, London, 1992, p. 95.

11 A new translation of *Till Eulenspiegel*, together with the original woodcuts, is available in the World's Classics series, Oxford, 1995. See also Werner Mezger's splendidly illustrated *Narrenidee und Fastnachtsbrauch*, Constanz, 1991.

12 This broadsheet of *The Wonderful Spinnenstube* was published in 1650, but was designed by Barthel Beham (1502–40).

13 For Erhard Schön, see the exhibition catalogue *German Renaissance Prints* by Giulia Bartrum, British Museum, 1995.

14 See Eamon Duffy, *The Stripping of the Altars*, New Haven, 1992, p. 480.

15 For Antonio Piazza etc., see the essay by Adriano Mariuz on Domenico Tiepolo in *Masterpieces of Eighteenth-Century Venetian Drawing*, London, 1983, p. 75.

16 Confusingly, the protagonist of Domenico's series has become known in his anglicized form. See *The Punchinello Drawings*, Adelheid Gealt, London, 1986.

17 Pierre Schneider, in his outstanding monograph on *Matisse*, London, 1984, p. 129.

18 For *The Invisible Girl*, see E.T.A. Hoffman, *The Life and Opinions of the Tomcat Marr*, Penguin Classics, 1999, p. 126ff.

19 Victor Stoichita and Anna Maria Coderch, *Goya: The Last Carnival*, London, 1999. In Juliet Wilson-Bareau's catalogue, *Goya: Truth and Fantasy*, London, 1994, she refers on p. 100 to Domenico, 'with whom Goya was certainly in close contact.'

20 Pierre Gassier, *The Drawings of Goya. The Complete Albums*, London, 1973, p. 570.

21 For Goshelin's encounter with the Erl-King, see Bakhtin, *Rabelais and his World*, pp. 391–2.

22 See Max Beckmann, *Self-Portrait* in Words, Chicago, 1997, p. 187.

23 See Max Beckmann, *Der Zeichner und Grafiker*, Hamburg, 1979, p.73.

24 See John Ashbery, 'Red's Hero Sandwich' in *Red Grooms, A Retrospective*, Pennsylvania, 1985.

25 The same milieu later commemorated in the painted cut-outs of Grooms' lifelong friend, Alex Katz.

26 Red Grooms, interview with David Shapiro, Marlborough Gallery, New York, 1995.

27 The postman Ferdinand Cheval (1836–1924) built his ideal palace at Hauterives near Lyons over more than thirty years. Grooms has visited it at least twice. See Roger Cardinal, *Outsider Art*, London, 1972.

28 Robert Crumb, quoted in exhibition catalogue *High and Low*, Museum of Modern Art, New York, 1990, p. 226.

29 Mikhail Bakhtin, *Problems of Dostoevsky's Poetics*, Manchester, 1984, p. 107.

Exaggeration and Degradation:
Grotesque Humour in Contemporary Art
Roger Malbert

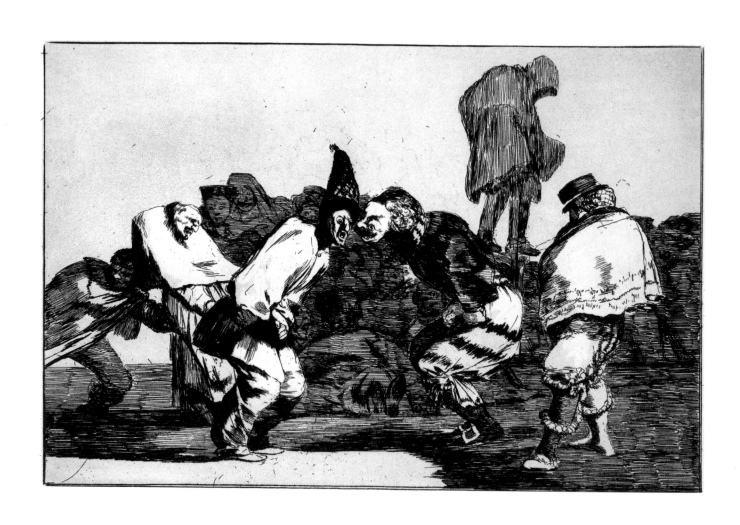

Most theories of Carnival invoke nostalgia for an authentic popular culture, spontaneously creative, communal and steeped in tradition. Carnival is inseparably linked in the European mind with Christianity, and discourse on the subject tends to be governed by the conventional dualisms of 'high' and 'low', order and disorder, government and the people, God and the devil. These polarities set the terms for the radical reversals we expect of carnivalesque imagery. And they explain why the romantic idea of Carnival as innately subversive is so questionable. Carnival, like art, is authorized transgression, framed by the surrounding order in time and place. When the frame constricts, the crowd may rebel, but the essential impulse of Carnival is positive, regenerative, a seasonal excess of high spirits.

Carnival's therapeutic function is central to Mikhail Bakhtin's conception of medieval 'folk humour', which he describes as 'the social consciousness of all the people. Man experiences this flow of time in the festive marketplace, in the carnival crowd, as he comes into contact with other bodies of varying age and social caste. The purpose of carnival laughter is to present a contradictory and double-faced fullness of life. Negation and destruction (the death of the old) are included as an essential phase, inseparable from affirmation'.[1] Today, in the postmodern era of electronic media and mass entertainment, we are entitled to be suspicious of this appeal for 'affirmative' art. Sarcasm and irony – precisely those tendencies that Bakhtin associates with Romantic individualism – may seem more appropriate and convincing.

A sceptical view of Carnival's social and aesthetic significance is offered by Umberto Eco in his essay, 'Frames of Comic Freedom'. Eco discounts claims for the 'revolutionary' implications of Carnival, regarding it less as a rebellion against the rule of law than 'a paramount example of law enforcement', which reminds us of the existence of the rule that it symbolically and temporarily flouts. Carnival 'parodies rules and rituals', he argues, 'but to be understood, rules must be recognized and respected'. Carnival is aligned with comedy, which should be distinguished from humour:

11
Francisco Goya
Carnival Folly (Disparate de Carnabal),
from *The Disparates, c.*1820
Etching and aquatint
The British Museum, London
© British Museum

'If there is a possibility of transgression, it lies in humour rather than in comedy. Humour does not pretend, like Carnival, to lead us beyond our own limits. It does not fish for an impossible freedom, yet it is a true movement of freedom. When a real piece of humour appears, entertainment becomes avant-garde. Humour is a cold carnival.'[2]

Eco's distinction provides a useful dialectical counterpoint to Bakhtin's populist enthusiasm; however, it is the latter's recipe for the carnivalesque, with its particular blend of grotesquerie and satire, that guides the present selection and discussion. So rich in imagery is Bakhtin's text that it is surprising how relatively little it has been applied to the visual arts. Carnival is, after all, a supremely visual phenomenon. Yet even when art revels in that irrational, disorderly atmosphere, it generally lacks two crucial ingredients: for what is Carnival without movement and music? Even performance art is usually the creation of a solitary individual – author and actor in one. Without the conviviality of others, art is a 'cold' Carnival indeed. If much is lost, however, something invaluable is gained in the translation from life to art: the power to reflect on the fleeting moment, to capture the ephemeral image and make it palpable. 'Carnivalesque' art is inevitably less light-hearted than the Carnival of the streets; it does not seek to escape but to confront, reminding the reveller of his mortality and the citizen that all is not right with the world.

In the brief account of grotesque imagery that follows, an eighteenth-century example serves as the point of departure to stress the historical continuities in the visual language. Thomas Rowlandson was one of the great precursors of today's cartoon; in style and spirit, he coexists with contemporaries like Robert Crumb and Steve Bell. His wash drawing, *The Exhibition Stare-case* (c.1800) is one of several satires he produced on the spectacle of the art exhibition; it shows a crowd of visitors tumbling over each other down the serpentine staircase at the Royal Academy in Somerset House. The art world is literally turned upside-down. Elderly connoisseurs stoop and squint through eyeglasses at the delights revealed. Another almost identical drawing (in the Paul Mellon Collection at Yale) substitutes for the urn in the niche under the stairs a classical nude sculpture, the Callipygian Venus – Venus of the beautiful buttocks[3] – thereby mocking the

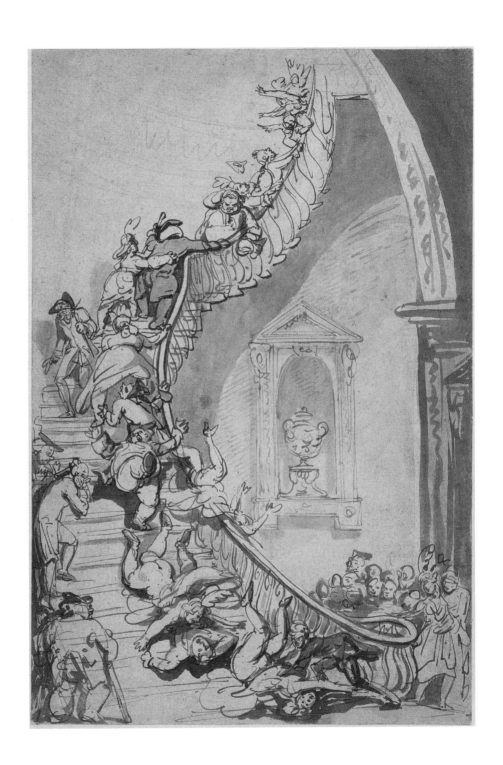

18
Thomas Rowlandson
The Exhibition Stare-case, c.1800
College Art Collections, University College
London

14
George Grosz
Travelling People (Fahrendes Volk), *c.*1918
Henry Boxer Gallery, London
© DACS 2000

distinction between 'art' and 'life', decency and indecency. In both drawings the sprawling women wear no underclothes, but an etched version has them in knickers. In Rowlandson's erotic drawings, he often contrasts a neo-classical ideal of feminine beauty with misshapen forms of aged lechery. His art fluctuates between two traditions, the Academic and a 'low' vernacular style of English comic illustration. In its fluency and grace, this drawing has affinities with his cheerful watercolours of rural scenes, and to other gentle satires on fashionable art lovers. The title's bad pun – *The Exhibition Stare-case* – is symptomatic of the humour of the gentleman's club or the inn. 'Rowlandson was more pointlessly sensual than Gillray', remarked the cartoonist David Low, 'Woman in all her conditions intrigued him more than liberty'.[4]

George Grosz's erotic imagination is altogether more aggressive than Rowlandson's, but he too enjoys the comic-grotesque possibilities of exposing the body's intimate parts in public; often he simply renders the clothes transparent. For Grosz, classical ideals of truth and beauty were to be positively resisted, and this he did by cultivating a scabrously infantile, graffiti-like style. Around the time that he drew *Travelling People* (c.1918), he was at the height of his creative powers. Discharged from the army in the previous year on grounds of insanity, he was a militant Communist and a leading member of the Berlin Dadaists, and was also painting some of his finest oils, in which Futurist-inspired compositions evoke the chaotic simultaneity of post-war city life. Here, the harsh, diagonal lines cancel any semblance of innocence and gaiety in the circus procession. An atmosphere of menace is suggested by the incidental violence – a man falls to his death from the tower and the drummer thumps his drum with a small human figure, as if to imply that the crowd that today is jocular and warm in its embrace may tomorrow cut your throat, or else, in an alternative scenario, rise up and revolt in earnest, possibly with terrible consequences.

Louise Bourgeois' cloth figure *Quilting*, resembles a monstrous rag doll, or a bauble, the fool's alter ego. It looks as if it was made to be handled and carried, like the giant bronze phallus that Bourgeois herself cradles in Robert Mapplethorpe's famous photograph of her, where her pose is eminently carnivalesque. The rough stitching around the eyes of *Quilting* resembles the angry scratched lines on many of Grosz's faces, rendering the eyes as pits of darkness rather than organs of sight. The grotesquely jutting tongue and breasts assert a sexuality that is cruelly negated by the stump of a torso; the pink patched fabric seems a ghastly evocation of the flannelette comforts of infancy – and of the infant's overheated, helpless rage. Yet both colour and material have other, kinder, associations for the artist: 'Pink is feminine. It represents a liking and acceptance of the self'.[5] The stitched patches imply healing as well as wounds:

> 'When I was growing up, all the women in my house were using needles [her mother restored tapestries]. I've always had a fascination with the needle, with the magic power of the needle. The needle is used to repair damage. It's a claim to forgiveness. It is never aggressive, it's not a pin'.[6]

Inevitably, Bourgeois' obsession with her childhood invites a Freudian reading, but she has declared firmly that her work 'is not Surrealist at all. It is Existentialist'. For Existentialism, the unconscious – so central to Surrealism and to Freudian psychoanalysis – is a fiction, incompatible with the idea of the responsible self as an undivided totality, free to choose, responsible even for the violent passions of early childhood.[7] Bourgeois' fierce totemic figure expresses powerfully these contradictory aspects of the subject as being-for-itself and being for others; it is an image of victim and aggressor in one, the head is both skull and mask, the tongue – instrument of self-disclosure in the 'talking cure' – a bud, a spike and a phallus. By this extreme compression, it conveys, like the solitary figures of Francis Bacon and Giacometti, the irreducible unity of the self in anguish and isolation.

89
Louise Bourgeois
Quilting, 1999
Private collection
Photograph courtesy Cheim & Read,
New York
© Louise Bourgeois/VAGA, New York &
DACS, London, 2000

83
Asger Jorn
Portrait of a Poet as a Young Prisoner, Uwe Lausen, 1962
Private collection, Amsterdam
© DACS 2000

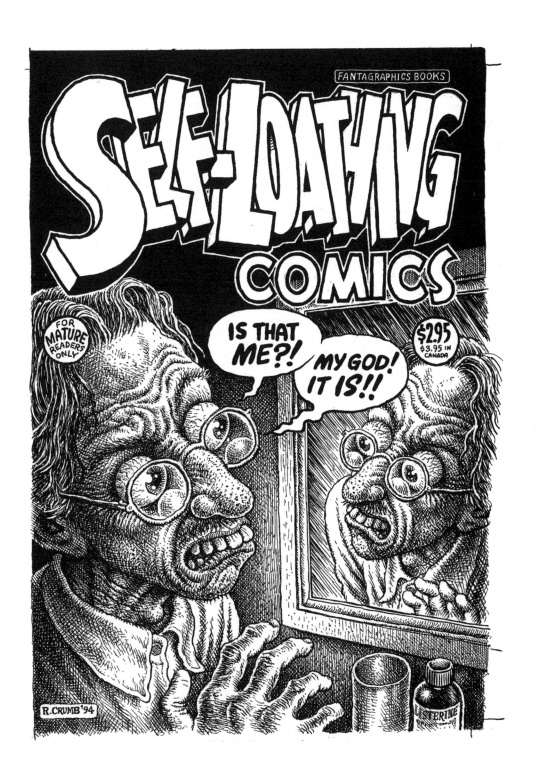

73
Robert Crumb
Self-Loathing Comics, 1994
Courtesy the artist
© The artist 2000

Images of alienation may seem contrary to the gregarious spirit of Carnival, with its dissolution of identities and merging of the self with the crowd. But behind every mask or disguise lurks a singular self-conscious being with an inescapable private destiny. If one way of expressing this ambivalence is by intense focus on the individual, another is by the proliferation of fantastic personages in carnivalesque abandon. Paula Rego shares with Bourgeois a deep absorption in memories of childhood, and her paintings of the early 1980s seethe with the kind of imagery found in children's book illustrations, comic-strips and popular prints. In *Rigoletto* and *Aida*, she takes stories from operas she had seen as a child with her father in Lisbon – each of which, incidentally, concerns a conflict between a girl and her parents over her choice of lover – mixing scenes from plots and subplots at different scales in a free-flowing narrative freize. Rigoletto, the hunchbacked jester, crouches at the centre of a medley of human and animal characters variously engaged in seduction, intrigue and murder. The restricted palette enables her to move rapidly across the picture plane at an automatist's pace, without correction or censorship. Rego's quirky, violent humour and intermingling of human and animal species owe something to 'World Turned Upside-Down' imagery and to the Chicago 'outsider' artist Henry Darger's 'Vivian Girls', which she encountered in the late 1970s. Both of these 'marginal' art-forms depict impossible fantasies with matter-of-fact decisiveness and clarity. Darger's visions of armies of naked little girls with penises, waging bloody battle with the forces of evil, constitute a perverse, private utopia. 'World Turned Upside-Down' images, such as the French nineteenth-century lithographs reproduced here, draw on a common pool of proverbs and stock peasant humour to depict a world where the 'natural order' – including relations between men and women, adults and children, humans and animals – is reversed. Thus, the pig skins the butcher, the duck roasts the cook on a spit, horses ride in man-drawn carriages and pheasants shoot at fleeing hunters. In the human domain, all hierarchies are overturned: the lord cleans his servant's shoes, wives beat their husbands, a pupil thrashes his teacher, people walk upside-down on their hands.

17
Paula Rego
Rigoletto, 1983
The artist courtesy of
Marlborough Fine Art, London
© The artist 2000

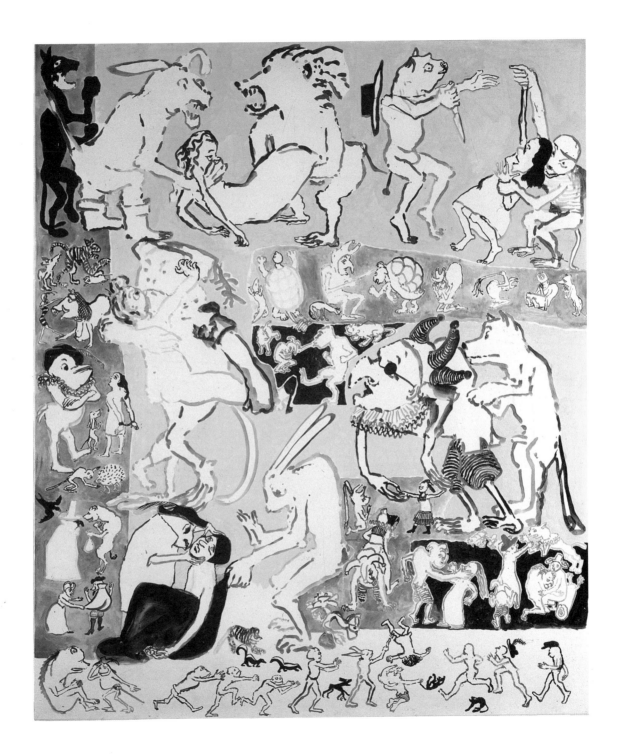

LE MONDE RENVERSÉ.

N1

Les femmes font la patrouille.

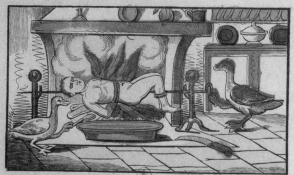

Le cuisinier à la broche, les oies la tournent.

La terre est en haut le ciel en bas.

Les femmes se battent en duel.

Imprimerie, Lithographie et Fabrique d'Images de DEMBOUR et GANGEL, à M⁶⁹.

LE MONDE RENVERSÉ.

L'oiseau qui tue le chasseur.

Le lièvre qui fait cuire le rôtisseur

L'homme et la femme marchent les jambes en l'air.

Les chevaux dans la diligence qui se font traîner par les voyageurs.

DE LA FABRIQUE DE PELLERIN, IMPRIMEUR-LIBRAIRE, A EPINAL.

37
Anon, published by Pellerin
The World Turned Upside-Down (Le Monde Renversé), plate 3, early 19th century
Cabinet des Estampes, Bibliothèque nationale de France, Paris

In *The Analysis of Performance Art*, artist Anthony Howell quotes Bakhtin on the medieval 'Feasts of Fools':

> 'From the wearing of clothes turned inside-out and trousers slipped over the head to the election of mock kings and popes the same topographical logic is put to work: shifting from top to bottom, casting the high and the old, the finished and completed, into the material bodily lower strata for death and rebirth.'[8]

Howell's performance *The World Turned Upside-down* takes this carnivalesque subject and plays a number of variations, in a sequence of dressing and undressing, upright or upside-down, clothes inside-out or the wrong way round – underpants over the head, trouser-legs for sleeves, socks over shoes. At each stage the artist barks corrections of the previously 'incorrect' arrangement, anticipating the adjustment necessary for the next: 'Well turned out; facing front; right way round. Back to front; well turned out; upside-down.' Enclosed with the artist in the performance space are two weaners – young pigs – whose incessant grunting conversation provides an animalistic soundtrack to his actions. The pig epitomizes the 'lower stratum': the gross, pink, hairless body wallowing in its own filth and eating random remains and slops is too close to the human not to have served as an efficient metaphor throughout history. Yet fatted up for a feast the pig symbolizes abundance and generosity. During Howell's performance cooked wieners (small sausages) are distributed to the audience, to the accompaniment of a sexually mocking song by Denise LaSalle: 'You can't get nothing straight between us / You know that I like jumbo franks / But you keep on bringing me wieners.' In this burlesque assault on masculine dignity, Howell employs the formality of suit and tie as a foil for absurd confusions of dress and self-exposure, exactly as Rowlandson ridicules aesthetic decorum with his naked behinds.

Anthony Howell
The World Turned Upside-down
Performed at Hollywood Leather,
London, November 1998
© The artist 2000

Transvestism and reversals of the sexes are perennial carnivalesque themes; whether such parodic inversion signifies rebellion against convention or a reinforcing of stereotypes, is open to question. In Britain, the lack of a masked carnival tradition is to some extent compensated for by the gay and fetish club scene where people recreate themselves and parade as outlandishly as any fashionable Regency 'monstrosity'. The most famous exponent of transgressive masquerade in London in 1980s and early '90s was Leigh Bowery, performance artist and costume designer, who performed with the dancer Michael Clark and modelled for Lucian Freud. His stage was the nightclub or the street, and his carnivalesque disguises and distortions of his gargantuan frame are legendary. Hilton Als describes his performance at Wigstock, a drag festival in New York in 1993:

> 'He strode forth with long, broad steps in a "look" of his own devising: knee-length green skirt, floral-print jacket with what appeared to be an enormous padded front, nylon mask. The mask covered his head, with a zip up the back and apertures for his eyes and mouth. Make-up was applied to the mask rather to than the face beneath: his lips were rendered huge, clown-like . . . the intensity of Bowery's absorption in his character was distinctly non-camp, violent and aggressive. After a minute or two . . . he began to moan, as if taken suddenly ill . . .
> He faced the audience and began to part his legs, still screaming, and in what seemed like a flash, a figure began to emerge from between his legs. It was a woman: bald, nude, slathered in "blood", lubricant and sausage links'[9].

This performance with Nicola Bowery re-enacts a traditional carnival masquerade – the fat man giving birth – which occurs also in the *commedia dell'arte* (for example, in the eighteenth-century play, *The Marvellous Malady of Harlequin*, where 'Harlequin is delivered of three boys')[10].

114
Fergus Greer
Leigh Bowery and Nicola Bowery, 1993
Courtesy Violette Editions, London
© Fergus Greer 1998, rosebudmedia.com

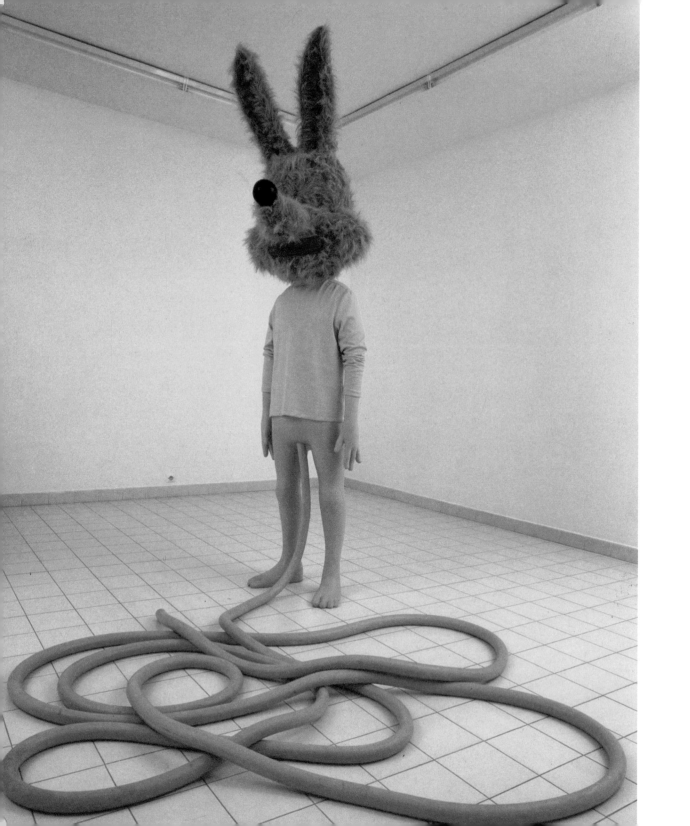

Bakhtin again:

'The grotesque image displays not only the outward but also the inner features of the body: blood, bowels, heart and other organs . . . Wherever men laugh and curse, particularly in a familiar environment, their speech is filled with bodily images. The body copulates, defecates, overeats, and men's speech is flooded with genitals, bellies, defecations, urine, disease, noses, mouths, and dismembered parts.'[11]

Bowery often vomited, urinated or defecated (with the aid of an enema) during performances, transgessing by these ritual acts of degradation some of society's deepest taboos. The American West Coast artist Paul McCarthy explored similar extremes of visceral chaos in his performances of the 1970s, in search of an abject poetics of orifices and bodily fluids. His enactments of infantile regression mimic the violent excesses of the Viennese Actionists,[12] but without their recourse to a shamanistic or Dionysian aura of ritual sacrifice. Instead of blood he uses manufactured foodstuffs. Framed by the banalities of suburban American consumer society, the iconoclastic artist negates all aspirations towards mystical transmutation, dissolving cultural signs into base matter. Tomato sauce and mayonaise and milk become obscene metaphors, the liquid oozing from a plastic bottle or tube as disgusting as any bodily excretion. 'The altar becomes the place where the sack is cut open', McCarthy has said, ' . . . the body sack or the animal sack, the sack meaning the skin.'

In *Bossy Burger*, McCarthy wears a chef's hat and apron and the character-mask of Alfred E. Neumann, *Mad* magazine's freckled, grinning icon of adolescent inanity. Laying out his ingredients on a chequered table-cloth, he proceeds with what appears initially to be a dysfunctional cookery demonstration. The emotional pitch intensifies and the actions grow more frenetic; the performance turns into a parody of an artist's creative contortions in the studio, as he paces the room pondering his next move, mixing up coloured substances and spreading them with delirious satisfaction ('I love my work, I love my work'), beating himself with the swinging doors. McCarthy has said of these performances:

118
Paul McCarthy
Spaghetti Man, 1993
Collection Frac Languedoc-Roussillon
Photograph: Richard Porteau
© The artist 2000

'In my work there's a kind of theatre . . . There were pieces that I made in the early '70s . . . where you don't represent getting shot, you actually get shot. That definition of performance as reality – as concrete – became less interesting to me. I became more interested in mimicking, appropriation, fiction, representation and questioning meaning.'[13]

Leigh Bowery treated his body as sculptural material to be moulded and remoulded at will, creating grotesquely exaggerated looks that confound conventional ideals of physical beauty and the erotic. For him the surface impression was the whole reality, as when he posed on a chaise longue in the window of the Anthony d'Offay Gallery in London in 1988, sticking out his tongue to the assembled onlookers, like a freak in a fairground side-show. Notions of disfigurement may converge with embellishment, depending on prevailing cultural values. 'Make-up' is an acceptable way of enhancing beauty or masking defects, but extremes of decoration, particularly when permanent, are perceived as denaturing the body, reducing it to a playground for shallow effects: at best, frivolous, at worst, blasphemous. For the rebellious, fashion-conscious young, the body often becomes a site of contestation if not outright battle – with piercings and tattoos among the chief weapons of attack on bourgeois sensibilities. Tattooed women have featured in fairground shows and circuses since the late nineteenth century, when the invention of the electric tattoo machine enabled elaborate designs to be spread across the skin with relative ease. The idea of engraving the whole surface of the body with an intricate mass of illustrations in permanent ink is fascinating to the average voyeur, and all the more so, perhaps, if the body in question is female. Performance artist Marisa Carnesky discovered in tattoos a double transgression, as a woman and as a Jew (the Torah prohibits self-decoration). Her performance *The Jewess Tattooess* mixes elements of the melodrama in early Yiddish theatre with the shock effects of fairground 'freak' shows. The 'tattooed lady somnambulist' sleeps on a bed of nails, levitates, prophesies and dances, reveals the writhing dragon tattooed on her back. Projections show her split in two as a pair of Siamese twins. She concludes the performance by adding a tattooed star of David to the expanding garter of stars on her thigh.

119
Paul McCarthy
Video still from *Bossy Burger*, 1991
Courtesy the artist
© The artist 2000

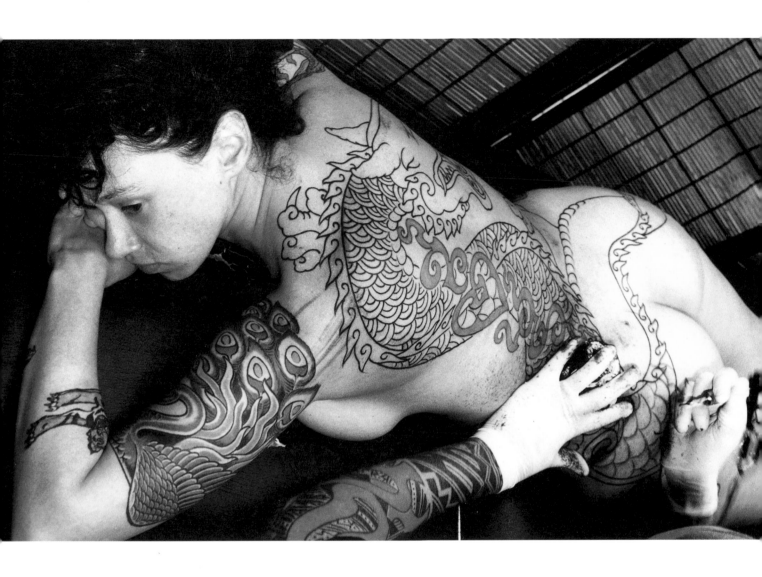

Marisa Carnesky, Live Artist
The Jewess Tattooess, 1999
Photograph: Johnny Volcano
© The artist 2000

If Paul McCarthy's performances are carnivalesque precisely when and because they are not 'for real', Carnesky's permanent tattoo casts her as a freak and outsider in the 'real' world, where the rules temporarily lifted for the artist and performer prevail. The challenge she presents to the treacherous distinction between art and life reminds us that the 'frame' that legitimizes art is itself imaginary; the world of the carnivalesque is present in every imagination.

The varieties of creative expression in the Carnival of the streets reflect its multiple sources in the imaginations of many individuals. That plurality defines an art-form that resists, and should resist, institutionalization and conformity. It may be that all attempts to theorize Carnival implicitly threaten to institutionalize it. In that case, 'real life' carnivalists may be glad to find here only tangential references to their world, as it has been reflected in art. Nevertheless, it is to them that this project is dedicated.

Exaggeration and Degradation:
Grotesque Humour in Contemporary Art
Footnotes

1 Mikhail Bakhtin, *Rabelais and his World*, trans. Hélène Iswolsky,
 Indiana University Press, Bloomington, 1984, p. 92.

2 Umberto Eco, V.V. Ivanov, Monica Rector, *Carnival*, Mouton
 Publishers, Approaches to Semiotics, 1984, pp. 7–8.

3 Noted by Victor I. Stoichita and Anna Maria Coderch, *Goya*:
 The Last Carnival, Reaktion Books, London, 1999, p. 103.

4 Quoted in Gordon Roe, *Rowlandson, The Life and Art of a British
 Genius*, Leigh-on-Sea, 1947.

5 Louise Bourgeois, *Destruction of the Father, Reconstruction of the
 Father. Writings and Interviews, 1923–1997*, Violette Editions,
 London, 1998, p. 269.

6 *ibid.* p. 222

7 'Existential psychoanalysis rejects the hypothesis of the existence
 of the unconscious; it makes the psychic act coextensive with
 consciousness.' Jean-Paul Sartre, *Being and Nothingness*, Methuen
 & Co Ltd, London, 1969, p. 570.

8 Quoted in Anthony Howell, *The Analysis of Performance Art*,
 Harwood Academic Publishers, Amsterdam, 1999, p. 18.

9 Hilton Als, *Leigh Bowery*, Violette Editions, London, 1999, p. 11.

10 P.L. Duchartre, *Italian Comedy*, Dover, New York, 1966, pp. 55–56.

11 Bakhtin, p. 319.

12 Otto Muehl, Hermann Nitsch, Günter Brus and others.

13 *Paul McCarthy*, Phaidon Press, London, 1996, p. 14.

The Late-Medieval Dutch Pilgrim Badges
Malcolm Jones

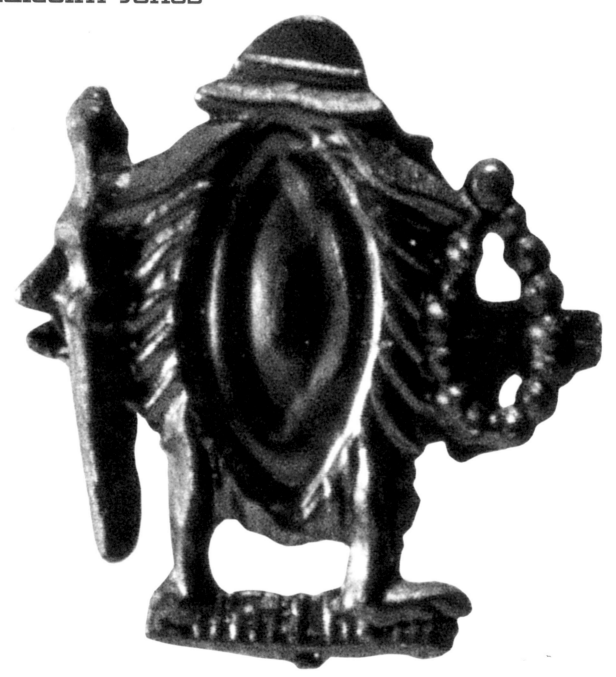

In recent years an extraordinary variety of lead badges has surfaced, mainly from the drowned villages of the Scheldt estuary in the Netherlands. The so-called pilgrim badges – souvenirs of visits to the shrines of saints – have long been familiar, but the non-religious badges have been unaccountably neglected, despite their disproportionate importance for late-medieval popular culture. They remain, however, an intriguing mystery for, unlike their religious counterparts, which appear in contemporary paintings sewn on to the hats and clothing of pilgrims, they are neither depicted nor even referred to in art. Thus we can only guess that they might have been worn as carnival decorations, and yet they certainly chime with the iconography of Carnival.

Lacking a particular context we can only speculate as to the badges' significance. Technically identical to the religious badges, they must similarly have been mass-produced, probably in their thousands; importantly, they must also have been very cheap, suggesting that they may rightly be classified as 'popular imagery'. Comparisons for the often bizarre forms they take, which aid in their interpretation, can be found in such 'marginal' media as manuscript drolleries, misericords and biscuit-moulds, or in literature – the *fabliaux* – and folk idiom.

The badges which take the form of sex organs or prominently display them, are undoubtedly the most striking to the modern eye. It has become customary to explain these as apotropaic, that is amulets employing the shock tactics of sexual display to repel – in both senses of the word – the unwelcome attention of the Evil Eye. One phallus-badge is surmounted by a diminutive figure holding a scroll on which the words *DE SELDE* are inscribed, Middle Dutch for 'The Luck[-bringer]' which lends support to this interpretation. The prominence of the phallic amulet in Roman life, including winged-phallus bronzes often hung with bells to drive away evil spirits, suggest that those badges which include a bell shown hanging from the *glans* may perhaps have been influenced by some medieval chance find from Roman times.

One example (cat. 22) still retains the albeit exaggerated form of a man with a decidedly prominent phallus (and anus); he holds a basket which may suggest the Dutch idiom to 'get the basket', that is to 'get the push'. Is this the badge

25
Anon
Vagina dressed as pilgrim, holding phallus staff and rosary, wearing hat, 1375–1425
Found in Reimerswaal, The Netherlands
3.3 x 1.9 cm
H.J.E. van Beuningen Collection

of a jilted and far-from-courtly lover? In cat. 27 (see p. 28) the man has been literally dis-membered, and is represented only by his breeches surmounted by an abstracted phallus flanked by two women. One possibility is that this is a version of the popular folk-theme of the Battle for the Breeches or, rather, for their contents. A perhaps remoter possibility is that we have here some proto-Protestant satire (the badge is dated 1400–50) against belief in the fertility-promoting power of the breeches of St Rombaut of Mecheln.

Some badges include the organs of both sexes, both bizarre in their different ways. Cat. 26 takes the form of a domestic spit on which a skewered phallus is roasting while a vagina below serves as a drip-tray to catch the fat. Cat. 23 shows a crowned vagina (the crown is in the form of three phalluses) carried on a litter by three phalluses on legs. Is this just 'emptily' humorous – laughter was, of course, also an ancient specific against the Evil Eye – or is it in some way satirical? Does it mock carnivalesque Marian processions in which the statue of the crowned Virgin was paraded through the streets? Cat. 25 depicting a vagina on pilgrimage seems similarly bizarre. All the accoutrements of the pilgrim are there: the 'cockle-hat' bearing the shell souvenirs of a visit to the shrine of St James of Compostella, rosary beads in one hand and a staff – here topped by a phallus – in the other. This must indeed mock at serious pilgrims or, at least, satirize those 'good time' pilgrims like Chaucer's Wife of Bath who 'koude muchel of wandrynge by the weye'. In Cat. 24, perhaps the most absurd badge of all, a stilt-walking crowned vagina wears the same triple phallus diadem. It is perhaps foolish to attempt a specific interpretation of such bizarreries; perhaps we should conclude merely that the combination of laughter at such palpable absurdity and shock at the exposure of the sexual icon provided the wearer with the perfect protective amulet.

24
Anon
Vagina walking on stilts crowned with three phalluses, 1375–1425
Found in Nieuwlande, The Netherlands
3.7 x 2.2 cm
H.J.E. van Beuningen Collection

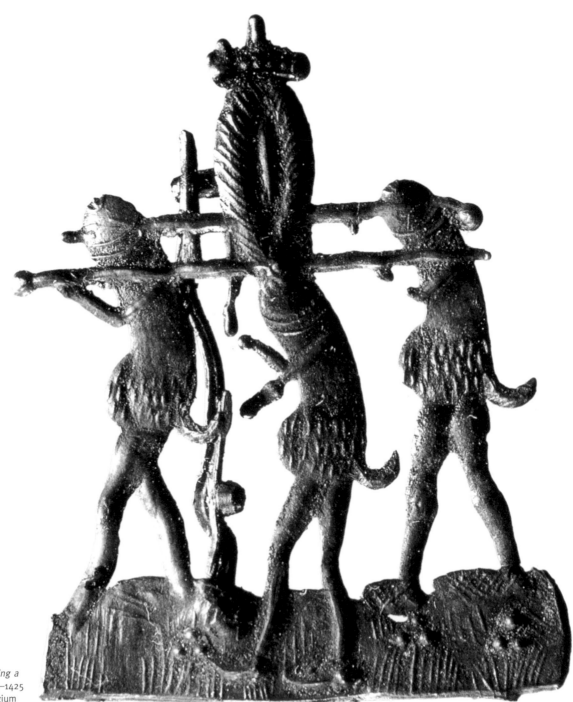

23
Anon
*Three phalluses carrying a
crowned vagina*, 1375–1425
Found in Bruges, Belgium
5.6 x 4.5 cm
H.J.E. van Beuningen
Collection

Further Reading

Barbara Babcock, ed., *The Reversible World, Symbolic Inversion in Art and Society*, Cornell University Press, Ithaca and London, 1978

Mikhail Bakhtin, *Rabelais and his World*, London, 1968

Peter Burke, 'The World of Carnival', in *Popular Culture in Early Modern Europe*, London, 1979

Michael Camille, *Image on the Edge*, London, 1992

Ruth Coates, *Christianity in Bakhtin*, Cambridge, 1998

James Ensor: Theatre of Masks (includes essays by Susan Canning and Timothy Hyman), London, 1997

Christa Grossinger, *The World Turned Upside Down*, London, 1997

Draper Hill, *Mr Gillray The Caricaturist*, London, 1965

Masquerading, The Art of the Notting Hill Carnival, Arts Council of Great Britain, London, 1986

Werner Mezger, *Narrenidee und Fastnachtsbrauch*, Konstanz, 1991

John W. Nunley and Bettelheim ed, *Caribbean Festival Arts: Each and Every Bit of Difference*, The Saint Louis Art Museum and University of Washington Press, Seattle and London, 1988

Alexander Orloff, *Carnival, Myth and Cult*, Vienna, 1981

Cesare Poppi, 'The Other Within', in *Masks*, ed. John Mack, London, 1994

Peter Stallybrass and Allon White, *The Politics and Poetics of Transgression*, Methuen, London, 1986

Johan Verberckmoes, *Laughter, Jestbooks and Society, in the Spanish Netherlands*, Macmillan, London, 1999

William Willeford, *The Fool and His Sceptre, A Study in Clowns and Jesters and Their Audience*, Edward Arnold Ltd, London, 1969

Les hommes sont montrés par les animaux.

36
Anon, published by Dembour et Gangel
The World Turned Upside-Down
(*Le Monde Renversé*), plate 3,
1842, (detail)
Cabinet des Estampes, Bibliothèque
nationale de France, Paris

List of Works

Note: all measurements are given as height x width x depth; page numbers after catalogue numbers indicate works which are illustrated. Works are grouped alphabetically by artist in four sections.

The Tumultuous Crowd

1
Anon, published by Martinet
Promenade des Jours Gras, c.1804
Coloured etching
20 x 25.6 cm
Cabinet des Estampes, Bibliothèque nationale de France, Paris

2
Anon, published by Martinet
Carnival Procession (Marche de Carnavale), c.1810
Coloured etching
23.8 x 38.6 cm
Cabinet des Estampes, Bibliothèque nationale de France, Paris

3 (pp. 15 and 17 detail)
James Ensor (1860–1949)
The Cathedral, 1886
Etching on paper
23.6 x 17.7 cm
Museum voor Shone Kunsten, Gent

4 (p. 64)
James Ensor
The Infernal Cortège, 1887
Etching on paper
21 x 25.8 cm
Museum voor Schone Kunsten, Gent

5
James Ensor
The Entry of Christ into Brussels, 1898
Etching on paper
35.5 x 24.8 cm
Museum voor Schone Kunsten, Gent

6
James Gillray (1756–1815)
Promis'd Horrors of the French Invasion, 1796
Coloured etching
32 x 43 cm
The British Museum, London

7
James Gillray
Devils in the Clouds, 1798
Pen drawing
24.6 x 20.3 cm
The British Museum, London

8 (p. 53)
James Gillray
The Card Table (Aristocrats Playing Faro), c.1800
Ink and wash
22.5 x 34.5 cm
The British Museum, London

9 (p. 49)
James Gillray
Voltaire Instructing the Infant Jacobinism, 1800
Oil painting on paper, heightened with white; traces of oil or varnish
27.4 x 20.4 cm
Print Collection, Miriam and Ira D. Wallach Division of Art, Prints, and Photographs, The New York Public Library, Astor, Lenox and Tilden Foundations

10 (pp. 46–47)
James Gillray
Recto: *Theatre of the World: The Revolutionary Wars*, 1805
Verso: *List of Subjects 'worthy of ye talents of British artists'*
Pencil, ink and watercolour
29 x 32 cm
Private collection, London

11 (p. 74)
Francisco Goya (1746–1828)
Carnival Folly (Disparate de Carnabal), from *The Disparates*, c.1820
Etching and aquatint
24 x 35 cm
The British Museum, London

12
Francisco Goya
Spanish Entertainment (Dibersion de Espana), from *The Bulls of Bordeaux*, c.1825
Lithograph
30 x 40.7 cm
The British Museum, London

13 (p. 69)
Red Grooms (b.1937)
At the Stroke of Midnight, 1976–92
Pencil, ink, watercolour on paper
96.5 x 127 cm
Saskia Grooms

14 (p. 78)
George Grosz (1893–1959)
Travelling People (Fahrendes Volk), c.1918
Pen, brush and ink on paper
50 x 29.2 cm
Henry Boxer Gallery, London

15
Karl Hubbuch (1891–1979)
The Knowing and the Blind, 1922
Drypoint
32.5 x 32.8 cm
The British Museum, London

16
Paula Rego (b.1935)
Aida, 1983
Acrylic on paper
240 x 203 cm
The artist, courtesy of Marlborough Fine Art, London

17 (p. 85)
Paula Rego
Rigoletto, 1983
Acrylic on paper
240 x 203 cm
The artist, courtesy of Marlborough Fine Art, London

18 (p. 77)
Thomas Rowlandson (1756–1827)
The Exhibition Stare-case, c.1800
Wash drawing
40 x 27 cm
College Art Collections, University College London

19
Paul Sandby (1730/31–1809)
after David Allen
The Horserace at Rome during the Carnival, 1781
Aquatint
34 x 51 cm
The British Museum, London

20 (p. 63)
Henri de Toulouse Lautrec (1864–1901)
A Calvacade at the Moulin Rouge (Une Redoute au Moulin Rouge), 1893
Lithograph
46 x 57.6 cm
Cabinet des Estampes, Bibliothèque nationale de France, Paris

21 (p. 33)
After van de Venne (1589–1662)
Carnival Parade (Vastenavondoptocht)
Engraving
19.6 x 28.2 cm
Collection Museum Boijmans van Beuningen, Rotterdam

The World Turned Upside-Down

22
Anon
Man with phallus, bare bottom, wearing hat and carrying basket, 1375–1425
Found in Bruges, Belgium
Lead badge
3.3 x 3.4 cm
H.J.E. van Beuningen Collection

23 (p. 101)
Anon
Three phalluses carrying a crowned vagina, 1375–1425
Found in Bruges, Belgium
Lead badge
5.6 x 4.5 cm
H.J.E. van Beuningen Collection

24 (p. 100)
Anon
Vagina walking on stilts crowned with three phalluses, 1375–1425
Found in Nieuwlande, The Netherlands
Lead badge
3.7 x 2.2 cm
H.J.E. van Beuningen Collection

25 (p. 98)
Anon
Vagina dressed as pilgrim, holding phallus staff and rosary, wearing hat, 1375–1425
Found in Reimerswaal, The Netherlands
Lead badge
3.3 x 1.9 cm
H.J.E. van Beuningen Collection

26
Anon
Phallus roasting on spit, vagina as dripping pan, 1375–1425
Found in Nieuwlande, The Netherlands
Lead badge
2 x 2.2 cm
H.J.E. van Beuningen Collection

27 (p. 28)
Anon
Two women with phallus on top of trousers, 1400–50
Found in Bruges, Belgium
Lead badge
6.3 x 3.3 cm
H.J.E. van Beuningen Collection

28
Anon
Misericord: Sowing, with cock-rider, c.1375
Wood
30 x 66.5 x 18 cm
Dean and Chapter of Lincoln Cathedral

29 (p. 27)
Anon
Misericord: *Two men in tunics threshing wheat with two flails, flanked by monsters*, c.1410
Wood
36.5 x 57 x 14.5 cm
Victoria & Albert Museum, London

30 (p. 27)
Anon
Misericord: *Man loading farm cart with sheaves, flanked by monsters*, c.1410
Wood
35.5 x 57 x 13 cm
Victoria & Albert Museum, London

31
Anon
Misericord: *Man piling sheaves in stock, flanked by monsters*, c.1410
Wood
35.5 x 58 x 14 cm
Victoria and Albert Museum, London

32
Anon
Three rabbits, their ears joined together, larking about on ground covered with flowers and fallen branches, 17th century
Circular copper engraving
25.5 x 25 cm
Cabinet des Estampes, Bibliothèque nationale de France, Paris

33
Anon
The Fools (Les Ridicules), 17th century
Circular copper engraving
25.5 x 25.6 cm
Cabinet des Estampes, Bibliothèque nationale de France, Paris

34
Anon
The World Turned Upside-Down (Il mondo alla riversa), late 16th/early 17th century
Engraving
39.4 x 51 cm
Cabinet des Estampes, Bibliothèque nationale de France, Paris

35 (p. 102)
Anon, published by Dembour et Gangel
The World Turned Upside-Down (Le Monde Renversé), plate 1, 1842
Stencil-coloured wood engraving
27.6 x 43.5 cm
Cabinet des Estampes, Bibliothèque nationale de France, Paris

36 (p. 102)
Anon, published by Dembour et Gangel
The World Turned Upside-Down (Le Monde Renversé), plate 3, 1842
Stencil-coloured wood engraving
27.1 x 44 cm
Cabinet des Estampes, Bibliothèque nationale de France, Paris

37 (p. 87)
Anon, published by Pellerin
The World Turned Upside-Down (Le Monde Renversé), plate 3, early 19th century
Stencil-coloured wood engraving
26.5 x 42.7 cm
Cabinet des Estampes, Bibliothèque nationale de France, Paris

38 (p. 6)
Anon, Broadsheet
The Miller's Man, Belfast, 1840
Woodcut
52 x 42.6 cm
The British Museum, London

39 (p. 22)
Anon, Flemish
The Everlasting Regeneration of Foolishness (A Great Hen Hatching Fools), 16th century
Oil on panel
37.3 x 46.3 cm
Université de Liège (Belgium), Collections artistiques

40 (p. 30)
Anon, German
The Wonderful Spinnenstube, c.1650
Engraving
36.5 x 27 cm
The British Museum, London

41
Anon, Russian Lubok
Cat's Funeral, c.1850
Coloured woodcut
36 x 56 cm
The British Museum, London

42
Anon, published by Bowles and Carver
The Follys of Mankind, 1790
Engraving
40.2 x 53.5 cm
The British Museum, London

43 (p. 29)
After Hieronymus Bosch (c.1450–c.1516), **engraved by Jerome Cock**
Ship of Fools, 1559
Engraving
22.9 x 29.8 cm
Private collection, London

44 (p. 20)
Pieter Bruegel (c.1525–69)
(or Crispin Van den Broek after Bruegel)
Fool Drinking on an Egg, c.1559
Silverpoint drawing
17.5 x 18 cm
The British Museum, London

45 (p. 23)
Pieter Bruegal
The Witches of Maleghem, 1559
Engraving
32.3 x 46 cm
The British Museum, London

46 (p. 37)
After Pieter Bruegel
Orson and Valentin, c.1566
Woodcut
28.8 x 42.1 cm
The British Museum, London

47
After Pieter Bruegel
The Land of Cockaigne, c.1566
Engraving
20.5 x 27.5 cm
The British Museum, London

48
George Dance the Younger (1711–1825)
This exquisite painting . . . The Island of Sumatra
Grey wash, pen and brush on paper
12.1 x 9.4 cm
Lent by the Syndics of the Fitzwilliam Museum, Cambridge

49 (p. 7)
Eugène Delacroix (1798–1863)
The Censors Moving House (Le Déménagement de la Censure), 1820
Lithograph
23.2 x 32.8 cm
The British Museum, London

50
James Ensor (1860–1949)
Demons Trouncing Angels and Archangels, 1886
Etching on paper
23.6 x 17.7 cm
Museum voor Schone Kunsten, Gent

51 (p. 52)
James Gillray (1756–1815)
The Invisible Girl (The Little Girl in the Globe), after 1800
Pen and ink and graphite
33 x 47.3 cm
Print Collection, Miriam and Ira D. Wallach Division of Art, Prints, and Photographs, The New York Public Library, Astor, Lenox and Tilden Foundations

52
Francisco Goya (1746–1828)
Ridiculous Folly (Disparate Ridiculo), from *The Disparates*, c.1820
Etching, aquatint and drypoint
21.3 x 32.8 cm
The British Museum, London

53
Francisco Goya
Men in Sacks, from *The Disparates*, c.1820
Etching and burnished aquatint
21.3 x 32.8 cm
The British Museum, London

54 (p. 70)
Red Grooms (b.1937)
Fat Feet, 1966
16 mm film transferred to video
Running time: 19 minutes
Courtesy the artist

55
Hondius, 17th century *(after Bruegel?)*
Fools, 1642
Engraving
11.7 x 15.5 cm
The British Museum, London

56
Neil Jeffries (b.1959)
Take a Drug, 1994–96
Oil on aluminium
104 x 185 x 90 cm
Courtesy Angela Flowers Gallery, London

57 (p. 31)
Erhard Schön (c.1491–1542)
The Fool-eater, c.1530
Coloured woodcut
46 x 37 cm
The British Museum, London

58 (p. 24)
Domenico Tiepolo (1727–1804)
The Birth of Punchinello, 1802
Wash drawing
29.2 x 41.9 cm
Executors of the late Sir Brinsley Ford

59 (p. 45)
Domenico Tiepolo
Punchinellos with a Giant Crab, 1802
Wash drawing
29.2 x 41.9 cm
Executors of the late Sir Brinsley Ford

60 (p. 42)
Giambattista Tiepolo (1696–1770)
Pulcinella's Kitchen, c.1735
Oil on canvas
104 x 165 cm
Trustees of the Leeds Castle Foundation

61 (p. 44)
Giambattista Tiepolo
Pulcinella, c.1743
Ink and wash
30 x 42.6 cm
Courtauld Gallery, Courtauld Institute of Art, D.1952.RW.2475

62
Fred Uhlman (1901–85)
Ship of Fools (Le Bateau de Fous 1)
Pen, indian ink, brown ink and crayon on paper
22.2 x 32.5 cm
Lent by the Syndics of the Fitzwilliam Museum, Cambridge

The Comic Mask

63
Anon
Roitschäggätä mask (Lötschental), c.1920
Wood
43 x 24 x 16 cm
International Carnival and Mask Museum, Binche

64
Anon
Roitschäggätä mask, c.1920
Wood
53 x 35 x 19 cm
International Carnival and Mask Museum, Binche

65
William Austin (1721–1820)
Long Thomas etc. 'In their Natural Masks', 1773
29.8 x 37.5 cm
Etching
Collection Matthew Bateson

66
M Bartholet or M Josef Grassner
Mask with Twisted Mouth (Masque à bouche tordue) (Flums), c.1900
Wood
43 x 24 x 16 cm
International Carnival and Mask Museum, Binche, Belgium

67
Max Beckmann (1884–1950)
Theatre, 1916
Drypoint
12.6 x 17.5 cm
The British Museum, London

68
Max Beckmann
Brothel Scene, 1918
Drypoint
21.5 x 25.5 cm
The British Museum, London

69 (p. 67)
Max Beckmann
Madhouse, 1918
Drypoint
25 x 29.8 cm
The British Museum, London

70 (p. 66)
Max Beckmann
The Yawners, 1918
Drypoint
28.7 x 25 cm
The British Museum, London

71
Max Beckmann
First Study for Fastnacht (Carnival), 1920
32.3 x 23.6 cm
Pencil drawing
The British Museum, London

72
Max Beckmann
Self-portrait as Fairground Barker (Zirkus Beckmann), 1921
Drypoint
34 x 25.2 cm
The British Museum, London

73 (p. 83)
Robert Crumb (b.1942)
Self-Loathing Comics, 1994
Ink on paper
28 x 35.5 cm
Courtesy the artist

74
Honoré Daumier (1808–79)
A Man Laughing, early 1860s
Grey wash, pen and brush on paper
12.1 x 9.4 cm
Lent by the Syndics of the Fitzwilliam Museum, Cambridge

75
James Ensor (1860–1949)
Scène Carnivalesque, c.1890
Oil on wood panel
39 x 26 cm
Fondation Socin Del Vaduz

76 (p. 57)
J.F. Foulquier (1744–89)
All Looking at me, Laugh at me (Omnes Videntes Me Beriserunt Me), 1773
Etching
16.5 x 23.3 cm
Andrew Edmunds, London

77
Francisco Goya (1746–1828)
They Say Yes and Give their Hand to the First Comer (Et si Pronuncian y la mano alargan al primero que llega), plate 2 from *The Caprichos*, 1799
Aquatint
21.5 x 15 cm
The British Museum, London

78
Francisco Goya
Nobody Knows Himself (Nadie se conoce), plate 6 from *The Caprichos*, 1799
Aquatint
21.5 x 15 cm
The British Museum, London

79
Francisco Goya
The Filiation (La Filacion), plate 57 from *The Caprichos*, 1799
Aquatint
21.5 x 15 cm
The British Museum, London

80 (p. 55)
Francisco Goya
Comical Discovery (Comico descubrimiento), c.1824–25
Black chalk or lithographic crayon on grey/white paper
19.2 x 14.9 cm
Lent by the Syndics of the Fitzwilliam Museum, Cambridge

81 (p. 56)
After Goya
Seated Man with Winged Heads (Man Beset by Monsters), c.1827
Lithographic crayon
19 x 15 cm
The British Museum, London

82 (p. 71)
Philip Guston (1913–80)
Untitled (Klansmen), 1968
Charcoal on paper
45.7 x 61 cm
Alexander Walker Collection, London, courtesy the Timothy Taylor Gallery

83 (p. 82)
Asger Jorn (1914–73)
Portrait of a Poet as a Young Prisoner, Uwe Lausen, 1962
Oil on canvas
83.5 x 66 cm
Private collection, Amsterdam

The Grotesque Body

84 (p. 60)
Anon, published by Basset
Gargantua's Feast (Gargantua à son grand couvert), 1810–15
Coloured copper engraving
23.5 x 31.7 cm
Cabinet des Estampes, Bibliothèque nationale de France, Paris

85
Anon, published by Noël
Madame Gargantua's Feast (Mme Gargantua à son grand couvert), 1810–15
Coloured copper engraving
23.3 x 31.7 cm
Cabinet des Estampes, Bibliothèque nationale de France, Paris

86 (pp. 11–13)
Anon, Flemish
Satirical Diptych, c.1520
Oil on panel
58.5 x 44 cm
Université de Liège (Belgium), Collections artistiques

87 (p. 50)
William Austin (1721–1820)
The Anatomist Overtaken by the Watch, 1773
27.2 x 37.5 cm
Etching
Private collection, London

88
William Austin
A Macaroni Ass-match, 1773
27.4 x 39.5 cm
Etching
Collection Matthew Bateson

89 (p. 81)
Louise Bourgeois (b.1911)
Quilting, 1999
Pink fabric
22.2 x 67.3 x 29.8 cm
Private collection

90
Leigh Bowery (1961–94)
Costumes, headgear and artefacts
Lent by Nicola Bateman, installed with the help of Ninda King

91
Leigh Bowery
Performance at Anthony d'Offay Gallery, London, 11–15 October 1988
Video running time: 60 minutes
Courtesy Cerith Wyn Evans and Anthony d'Offay Gallery

92
Pieter Bruegel (c.1525–69), **engraved by Pieter van der Heyden**
The Fat Cooks (De Vette Keuken), 1563
Engraving
21 x 22.2 cm
Museum Boijmans van Beuningen, Rotterdam

93
Pieter Bruegel, engraved by Pieter van der Heyden
The Thin Cooks (De Magere Keuken), 1563
Engraving
20.8 x 28 cm
Museum Boijmans van Beuningen, Rotterdam

94 (p. 38)
Jacques Callot
Title plate from *I Gobbi*, 1616
Etching
6.2 x 8.5 cm
The British Museum, London

95
Jacques Callot
Plate from *I Gobbi*, 1616
Etching
6.3 x 9 cm
The British Museum, London

96
Jacques Callot
Plate from *I Gobbi*, 1616
Etching
6.6 x 8.6 cm
The British Museum, London

97 (p. 39)
Jacques Callot (1592/93–1635)
Plate from *Balli di Sfessania*, c.1621/22
Etching
7.6 x 9.5 cm
The British Museum, London

98
Jacques Callot
Plate from *Balli di Sfessania*, c.1621/22
Etching
6.9 x 9 cm
The British Museum, London

99
Marisa Carnesky (b.1971)
Serpentina Serpentina, 1999
Video film written and performed by Marisa Carnesky, 'Jewess Tattooess'
Directed by Alison Murray

100 (p. 58)
Honoré Daumier (1808–79)
Gargantua, 1831
Lithograph
25.1 x 34 cm
Collection John Wardroper

101 (p. 65)
James Ensor (1860–1949)
Battle of the Down-and-outs (Combat des Pouilleux), 1888
Etching on paper
22.9 x 28 cm
Museum voor Schone Kunsten, Gent

102 (p. 35)
Peter Flötner (c.1486–1546)
A Human Sundial, c.1530
Woodcut
19.7 x 31.2 cm
The British Museum, London

103 (p. 34)
Peter Flötner
Fool, c.1530
Woodcut
23.4 x 30.5 cm
The British Museum, London

104 (p. 32)
Peter Flötner
The Procession of Gluttony, 1540
Woodcut
25.4 x 27.6 cm
The British Museum, London

105
Peter de Francia (b.1921)
Disparates, 1968
Charcoal on paper
74.9 x 54.6 cm
Private collection

106
Pier Ghezzi (1674–1755)
Man Laughing before an Easel
Ink
43.7 x 58.8 cm
Courtauld Gallery, Courtauld Institute
of Art, D.1952.RW.3834

107 (p. 51)
James Gillray (1756–1815)
*Curing John Bull of his Canine
Appetite (Pitt pulling out John Bull's
teeth)*, 1796
Pen, ink and graphite
33.4 x 26.8 cm
Print Collection, Miriam and Ira
D. Wallach Division of Art, Prints, and
Photographs, The New York Public
Library, Astor, Lenox and Tilden
Foundations

108 (p. 61)
James Gillray
Midas, 1797
Coloured etching
35.5 x 25 cm
The British Museum, London

109
James Gillray
Basting of an Ox, after 1800
Red ink
43.6 x 58.8 cm
Courtauld Gallery, Courtauld Institute
of Art, D.1952.RW.3082

110
Fergus Greer
Leigh Bowery (1961–94), 1993
Black and white photograph
35.6 x 27.9 cm
Courtesy Violette Editions, London

111
Fergus Greer
Leigh Bowery, 'Black Fetish', 1993
Black and white photograph
35.6 x 27.9 cm
Courtesy Violette Editions, London

112
Fergus Greer
Leigh Bowery, 'Future Juliet', 1991
Black and white photograph
54 x 45.1 cm
Courtesy Violette Editions, London

113
Fergus Greer
Leigh Bowery, 'Madame Garbo',
1993
Black and white photograph
35.6 x 27.9 cm
Courtesy Violette Editions, London

114 (p. 91)
Fergus Greer
Leigh Bowery and Nicola Bowery,
1993
Black and white photograph
47.3 x 41.3 cm
Courtesy Violette Editions, London

115 (p. 70)
Red Grooms (b.1937)
Tattoo Parlor, 1998
Enamel on styrofoam on epoxy
123.2 x 104.1 x 17.8 cm
Private collection, Connecticut

116 (p. 41)
**Il Guercino (Giovanni Francesco
Barbieri)** (1591–1666)
Man Frightened by a Monster,
c.1620
Pen, ink and brown wash
15 x 22.2 cm
Board of Trustees of the National
Museums and Galleries on
Merseyside (Walker Art Gallery,
Liverpool)

117
William Hogarth (1697–1764)
*The Punishment Inflicted on Lemuel
Gulliver (The Political Clyster)*, 1726
Engraving
21.5 x 31.5 cm
The British Museum, London

118 (p. 92)
Paul McCarthy (b.1945)
Spaghetti Man, 1993
Fibreglass, metal, urethane rubber,
acrylic fur, clothing
254 x 84 x 57 cm; penis length 1270 cm
Collection Frac Languedoc-Roussillon

119 (p. 94)
Paul McCarthy
Bossy Burger, 1991
Performance video
Running time: 58 minutes, 59 seconds
Courtesy the artist

120
Erhard Schön (c.1491–1542)
Picture-puzzle with Excreting Peasant,
1538
Woodcut
24.5 x 89 cm
The British Museum, London

121
Giambattista Tiepolo (1696–1770)
Caricature of a Standing Man in a Hat,
c.1754–62
Pen, brown ink and wash
20.3 x 13.3 cm
Lent by the Syndics of the Fitzwilliam
Museum, Cambridge

122
Giambattista Tiepolo
Female Caricature, c.1754–62
Pen and wash
18 x 10.8 cm
The British Museum, London

123 (p. 18)
Hans Weiditz (c.1500–36)
Fat Man, 1521
Woodcut
27.5 x 21 cm
The British Museum, London

124 (p. 19)
Hans Weiditz
Grotesque Woman, 1521
Woodcut
30 x 21.3 cm
The British Museum, London

Performance Works

Marisa Carnesky (b.1971)
Penny Slot Somnambulist
Gallery-based performance installation
Brighton Museum and Art Gallery,
5 and 6 May 2000

Anthony Howell (b.1945)
The World Turned Upside-down
Performance with two weaners
Fabrica, Brighton, 6 May 2000
First performed Hollywood Leather,
London, November 1998